ELEANORE MIKUS

SHADOWS OF THE REAL

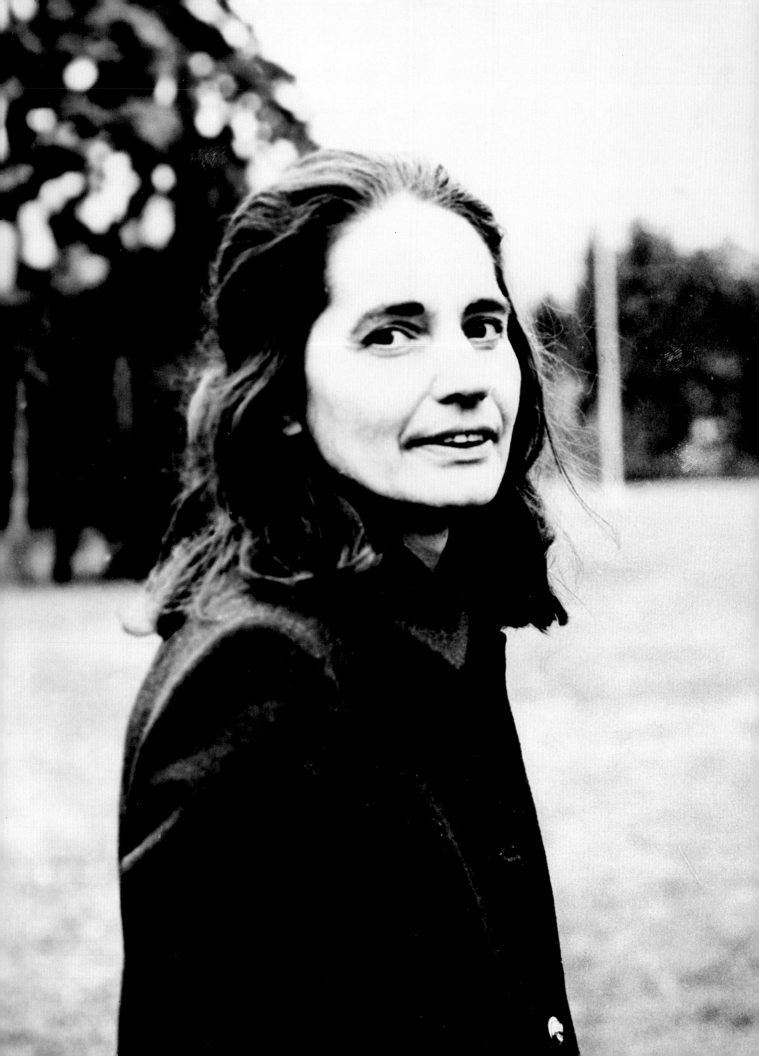

ELEANORE MIKUS
SHADOWS OF THE REAL

ROBERT HOBBS and JUDITH BERNSTOCK

With a Foreword by THOMAS W. LEAVITT

GROTON HOUSE
Ithaca, New York

IN ASSOCIATION WITH THE
UNIVERSITY OF WASHINGTON PRESS
Seattle and London

Groton House, Ithaca, New York, in association with the University of Washington Press, Seattle and London

Distributed by the University of Washington Press
P.O. Box 50096, Seattle, Washington 98145-5096

Library of Congress Catalog Card Number: 91-70861

ISBN 0-295-97116-9

Printed by The Stinehour Press
Design by Groton House

PRINTED IN THE UNITED STATES OF AMERICA

Partial support for *Eleanore Mikus: Shadows of the Real* was provided by the Dean's Fund for Excellence, College of Architecture, Art, and Planning, Cornell University.

FRONTISPIECE
Eleanore Mikus, 1969 (photo by Shepard Mallen)

CONTENTS

ILLUSTRATIONS

FOREWORD

ELEANORE MIKUS: Shadows of the Real is a most welcome addition to the literature on contemporary American art. This retrospective study, covering a span of more than thirty years, focuses on a major aspect of Mikus's work—paintings, reliefs, and prints that appear to be of a single tone. Although Eleanore Mikus follows a long tradition of abstract monochromatic works, imagination and sensitivity have led her into new territory. While sharing the austerity and sense of purity found in early suprematist paintings by Kasimir Malevich and Alexander Rodchenko, among others, her white, black, and gray works have a sensuousness and a subtlety that bring them into closer harmony with organic nature. As light and viewpoints change, evanescent shadows emerge and disappear on the gently modulated surfaces. These works are real in the way that clouds are real, ever changing and ephemeral yet endlessly renewed. In their radical understatement they are close in spirit to the approach and methods of Zen Buddhism. The writings in this book by Professors Robert Hobbs and Judith Bernstock illuminate the salient dimensions of these seemingly simple nonobjective images and help us understand both their origins and their emotional suggestiveness.

Mikus's minimalist works, presented in considerable depth in this volume, tell only part of the story of her remarkable creative production. Not featured here are the new-expressionist paintings (or perhaps proto-neo-expressionist paintings) that she painted for fifteen years, beginning in the late sixties. When we first confront these strident, crude, cartoon-like figurative images, they seem incongruous with the sensitive and subtle forms of the minimalist works. But when we remember that Eleanore Mikus is familiar with the philosophies of the East and especially with the paradoxes of Zen koans (riddles) and the occasionally startling behavior of Zen teachers, we see that these contrasting styles are indeed emanations from the same creative spirit. The dominant features of each style are latent in the other. That story, however, although well worth telling, will have to wait for a second volume.

The works we are studying here have plenty to teach us by themselves. The only experience that would add substantially more to our understanding of Eleanore Mikus and her minimalist works than this handsomely illustrated book would be the opportunity of viewing an extensive exhibition of thirty years of her paintings, constructions, and prints. Let us hope that one day soon that exhibition will be available to us.

THOMAS W. LEAVITT
Director
Herbert F. Johnson Museum of Art
Cornell University

ACKNOWLEDGMENTS

BOOKS ARE ELABORATE productions involving the expertise and commitment of many individuals. We are particularly grateful to the people who worked closely on *Eleanore Mikus: Shadows of the Real.* Their concern and their ability to work both independently and as a team have made this project an enjoyable and worthwhile endeavor.

In 1987 Carlo Lamagna, formerly of the Carlo Lamagna Gallery in New York City, first suggested the idea of a catalogue of Mikus's work. He offered encouragement along the way as the project developed into a book.

Cathleen Anderson, former registrar at the Herbert F. Johnson Museum of Art, Cornell University, provided advice and direction in the early stages of the project, and her encouragement has been important.

Linda Allen served an essential role in typing the early drafts; we also appreciate her enthusiasm.

Lee Melen spent time and effort ensuring the quality of the photographs. He recognizes that good art photography is a subtle form of appreciation and interpretation.

Anna Geske, executive director of the Council of the Creative and Performing Arts, Cornell University, devoted an incredible amount of her free time to the book. She served informally as editor, proofreader, adviser, and consultant. We thank her for her encouragement, enthusiasm, and attention to detail.

Jill Hartz, community relations coordinator of the Herbert F. Johnson Museum of Art, catalogued the prints. She organized and condensed a vast amount of detailed information regarding this material and has thus clarified the history of Mikus's development.

Lynn Colvin was the final editor. Her common sense and appreciation of straightforward prose have proven helpful to both authors.

We are deeply appreciative of Eleanore Mikus's help, encouragement, generosity, and humor. She has enthusiastically endorsed the project and readily given us access to her personal archives. She has responded directly and thoughtfully to our questions about her art, development, and personal life. We thank her for her unflagging efforts to make the project a reality, and we acknowledge as well the help of her mother, the late Bertha Englot Mikus, who set an example of courage, toughness, and good humor for her daughter to follow. We respectfully dedicate this book to her memory.

ROBERT HOBBS

JUDITH BERNSTOCK

ELEANORE MIKUS

SHADOWS OF THE REAL

ROBERT HOBBS

Tablet 15, 1962
Acrylic on wood
16 × 12 inches

IN HIS BOOK *Populuxe* Thomas Hine describes the widespread prosperity in the United States in the 1950s and 1960s that enabled mass-consumer taste to indulge in cars with massive tail fins, TV dinners, and Barbie dolls.[1] It was a gaudy age of middle-class opulence, when design ideas were applied to everyday objects to increase their desirability and marketability, when planned obsolescence became the norm, and when quantity clearly outweighed the virtues of quality. Given the sheer profusion of new products, the wealth of applied decoration, and the mania for new decorator colors that included, in cars and appliances, such novel two-tone combinations as turquoise and taupe, charcoal and coral, and canary and lime, it is no wonder that committed young artists in the late fifties and early sixties were repulsed by the excesses of the "Populuxe era" and fed up as well with the profusion of color, brushwork, and emotional involvement in the then-dominant avant-garde style, abstract expressionism. While some artists, such as John Chamberlain, Richard Stankiewicz, Bruce Connor, and Edward Kienholz, examined the flip side of opulence by emphasizing its effects in richly variegated assemblages of materials gathered from automotive graveyards, junk piles, and secondhand stores,[2] artists such as Eleanore Mikus searched for an understated means that would encourage viewers to savor subtleties instead of excesses and essences instead of illusions.

Eleanore Mikus's shadows of the real are tablets made between 1960 and 1968 and again in the 1980s after a hiatus of almost fifteen years. They are concerned with making illusions real by pushing the surfaces of her paintings to the point where they are capable of casting shadows (fig. 1). This art is informed by Zen Buddhism, which began to fascinate Americans after World War II and became an active force in both the artistic and the literary world.[3] Zen enabled Americans to find universals in their everyday world. They appreciated its irreverence, humor, toughness, and ability to shock people into an understanding of the real. They liked the fact that Zen was a nonmystical mysticism, a nonorthodox belief, and a nonsanctimonious way of achieving enlightenment; in short, they liked Zen because it opened life up to direct experience and meaning. Zen encouraged artists to avoid the pretentiousness of many styles of modern art as they examined ways that works of art could seem to be mere objects and yet remain stirring metaphors. Their understanding of Zen allowed them to distill the everyday into a style and at the same time avoid the vulgarity of

Fig. 1. Mikus, *Tablet 65,* 1963, 1966; white epoxy on wood, 16 × 12 3/4 inches; private collection

In the descriptions of works of art throughout this book height precedes width. When three dimensions are given, the last is the depth. Works are in the collection of the artist unless otherwise indicated.

15

Fig. 2. Robert Morris, *Untitled,* 1965; paint on plywood, two parts, each 96 × 96 × 24 inches; courtesy of the Leo Castelli Gallery, New York City

Fig. 3. Ben Nicholson, *Painted Relief,* 1939; paint on synthetic board on plywood, 32 7/8 × 45 inches; collection of the Museum of Modern Art, New York City; gift of H. S. Ede and the artist (by exchange)

the new in designs intended for the prosperous postwar American masses.

Although Mikus differs in remarkable ways from minimalists Carl Andre, Donald Judd, and Robert Morris (fig. 2), particularly in her regard for her materials and her refusal to see her work as blank, vacant, and boring,[4] she does share their interest in reducing artistic means to only a few elements in order to slow down perception and thought. In her art she wants to encourage appreciation for the small moments of life, when one stares almost absentmindedly at weathered pavement, worn bricks, shells on a beach, and water-washed stones.[5] Her work anticipates many aspects of mainstream minimalism, canonized in Barbara Rose's "A B C Art" of 1965, but it also represents a refinement of the English constructionist Ben Nicholson's work (fig. 3), particularly his carved Masonite reliefs, which Mikus admires.[6] Her low-key aesthetic requires viewers to take the necessary time to come to terms with small moments capable of catalyzing important epiphanies. It represents a quiet voice in the midst of the raucous hype of post–World War II mass prosperity and a calm that rises above much of the noise generated by advertising and idolization of the new. She names her works *tablets,* referring to the fact that people "from childhood . . . carry . . . some sort of notational record."[7] She composes them of pieces of wood that are worked to suggest long-term use. These works, through their association with change, wear, and endurance, are symbols for human resiliency.

The tablets rely on a negative presentation of the spiritual. In Mikus's words, "I prayed and prayed and prayed and my prayers were answered and the answer was no."[8] Even though she could not be termed a Zen follower, the humor of her statement reveals an understanding of the Zen preference for finding the universal in the mundane. Followers of Zen believe that one must silence the reasoning mind before one can begin to understand. Frequently Zen initiates concentrate on koans, paradoxes intended to frustrate the reasoning mind, and thus demonstrate its limitations and its inability to reach the far more important realm of intuitive knowledge. Similarly, Mikus avoids giving information in the tablets that would encourage a reasoned response. The inflected surfaces of her tablets, which present reality in terms of actual light and shadow rather than an illusion of light and shadow, are an analogy for the Zen recognition of the universal in the everyday.

Mikus discovered the tablets after two years of experimentation, which began in 1958, when she started using plastic glazes for a series of abstracted still lifes that continued to rely on an abstract expressionist vocabulary of overlapping biomorphic shapes (pl. 1). In 1960, after having taken courses at New York University, the New York Art Institute, and the Art Students League, she began thinking about paint as a form of glue and began to investigate the aesthetic potential of glue in *Window I* (pl. 7), which consists of

stamp hinges glued on wood, and in an even more experimental work of the same year (pl. 6), made of rabbit-skin glue, staples, and loose-leaf reinforcements on wood. Her choice of materials began to dictate a grid format, even more apparent in *Ortho* (pl. 4). Her use of new materials and her interest in serial imagery put her in the forefront of artistic innovation. Her *Window I* can be compared to Jasper Johns's *Grey Alphabets* of 1956 (fig. 4); her untitled experimental work of 1960 (pl. 6), to Carl Andre's *Cedar Piece* of 1964; and her *Garden* of 1959 (pl. 2), to Myron Stout's untitled work (no. 3) of 1956 (fig. 5).

Although Mikus accepts the idea of a rational substructure on the order of the grids in *Window I* and the untitled piece incorporating loose-leaf reinforcements, she does not allow a gridlike structure to dominate her pictures. She is more interested in playing with contradictions than in adhering to a system of logic. In *3 + 5* of 1959 (pl. 3) she joined three stretched canvases together and then painted two circles that span the divisions so that the circles create a compositional unity that the background denies. In *Ortho* she makes that breach of logic even more emphatic when she suggests a regular system of circles without subscribing to it; circles of various colors and sizes overlap only four of the six panels making up the composition. Her works, then, play on a Zen disregard for logic as they thwart the viewer's initial expectations.

Tablet 1 (pl. 11) is one of the few pieces in this series that is made up of pieces of wood glued to a plywood support. In this work Mikus continues to explore ideas about separate elements joined to make a whole, but the pieces of wood in *Tablet 1* allow her the freedom to join background and foreground into one forceful, oscillating plane. When discussing this work, Mikus compares it to the undulating planes making up the palm of the hand, worn heels on shoes, and uneven sidewalk pavements.[9] To achieve those uneven effects, she relied on the textures of roughly sawed pieces of wood, the resulting variations in spacing that occurred when joining them together again, and the subtle differences in surface planes resulting from judicious sanding. Because *Tablet 1* looks as if it were once a unified plane, subjected to wear and dismemberment before being reassembled in an attempt to reinstate a pristine quality, it communicates feelings of nostalgia.

In some of the tablets that followed *Tablet 1*, Mikus employed plywood with random industrial cuts (pls. 12, 14, 20). Sometimes she ripped the plywood with a saw to make additional cuts before joining the resultant pieces together with Weldwood glue and reinforcing them on the reverse with braces. In these pieces, as in the first tablet, the artist worked to achieve solidity and unity in spite of the cuts inflicted on the material. The image of unity prevailing over diversity and change in these pieces may have symbolized for her the new direction her work was taking.

Soon Mikus developed a way of making the tablets by

Fig. 4. Jasper Johns, *Grey Alphabets*, 1956; encaustic and newsprint on canvas, 66 × 49 inches; courtesy of the Menil Collection, Houston

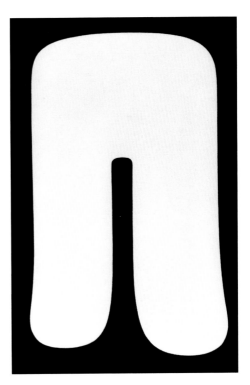

Fig. 5. Myron S. Stout, *Untitled (no. 3)*, 1956; oil on canvas, 26 × 18 inches; collection of the Carnegie Museum of Art, Pittsburgh; gift of Leland Hazard

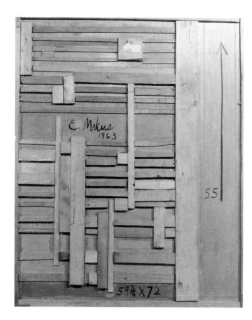

Fig. 6. Mikus, *Tablet 55*, 1963 (view of back); wood and Weldwood glue, 72 × 57 3/4 inches

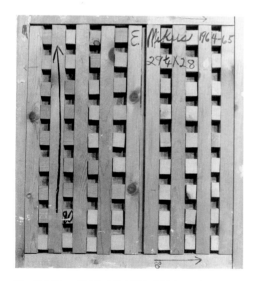

Fig. 7. Mikus, *Tablet 80*, 1964–65 (view of back); wood, Weldwood glue, and epoxy glue, 29 1/4 × 28 inches; private collection

working from the reverse to build the base structure before turning them over to assess their compositions (pls. 23, 25, 27, 36). She would begin working with a general idea and would take advantage of chance effects. She has outlined the process of constructing and painting the tablets:

1. I used my floor for an uneven surface. The more uneven, the better.

2. I cut plywood or Masonite into pieces—lots of small pieces, some larger, and some very large.

3. I placed them on the floor (all the time thinking how the front would look without actually seeing it, because it was face down).

4. I cut my braces and glued them on the seams, placed different weights for different pressures so that the front would have deep and shallow recesses and the lines between the sections would be narrow, very thin, wide, etc.—always thinking about the front while working the back.

5. I raised the piece, sometimes ripping it off the floor (because of the glue), and some of the floor would come with it. Sometimes it would work, and sometimes I'd work it out.

6. I assessed it and made some changes—sometimes not. I reversed it again and put the outside brace or frame on it (think of it as the frame a canvas is stretched over).

7. I beveled and sanded the sides. That is why some of my paintings are a sixteenth to an eighth of an inch off from side to side or top to bottom.

8. I put a coat of gesso on the work to see again how it would work and then put on more coats of gesso—six or so—and then the paint.

9. I worked the back to be sure it was braced well and filled in any gaps with support material [figs. 6, 7].

10. To all that there are a few exceptions. When making *Tablets 171* [pl. 49] and *173* [pl. 50], I glued pieces on the plywood, sized them with gesso, and then painted them.

11. I never used found objects for the tablets. If someone did not need a bit of two-by-four, I took it for the brace or frame. I used one-quarter-inch or one-eighth-inch plywood or Masonite. I burned out many tools and kept three or four paintings going at one time.

12. When creating fiberglass-on-plywood paintings, I used the same system. However, after I raised the paintings, I covered the surface with a thin piece of fiberglass and then used the resin to harden it.

13. When I created the fiberglass-shell paintings, I situated the form on the floor face up and put fiberglass and then the hardener on it. Then I turned the piece over and ripped the form out.

14. My one and only painting on aluminum was covered with fiberglass. It had no bracing on the back [see fig. 8, which represents a working state of *Tablet 170,* pl. 48].

15. Most paintings took me six weeks to a couple of years to complete.

16. I never used blocks of wood, except as utility braces, because the painting had to be thin enough to bend, twist, move, etc. I used pieces of thin wood or Masonite, for instance. MoMA's [pl. 32] is on Masonite.

17. When the painting was finished, I documented it in a black sketchbook: I sketched it, numbered it, and wrote down any pertinent information about it [fig. 9]. Photography at that time was not able to capture the nuances in the painting.[10]

Fig. 8. Mikus, *Tablet 170,* 1967–68 (working state); fiberglass on aluminum, 24 × 23 1/2 inches

The backs of *Tablet 55* and *Tablet 80* (see pls. 23, 30) indicate her range, from an improvisational composition (fig. 6) to a carefully plotted structure (fig. 7). Both works demonstrate Mikus's need to compose the tablets out of real substances with depth so that the shadows are actual, not simulated.

In the 1960s Mikus used sandpaper to refine the edges of the wood—both plywood and Masonite—and arrive at a mellow, fluctuating surface that looks worn (pls. 18, 22). She frequently compares the tablets to driftwood or to surfaces worn smooth by the touch of innumerable hands.[11] On one occasion she said: "When people put tokens in for the subway, they then touch the surface of the turnstile and gradually wear away the paint and the wood. I like to get that quality in my tablets."[12] That quality of wear, which is crucial to her tablets, distinguishes them from monochromatic paintings by other artists such as Agnes Martin and Robert Ryman. The look of wear and erosion unifies her surfaces and makes them harmonious. One might even say that Mikus caresses surfaces, while most monochromatic artists paint flat planes.

The quality of old age that imbues the tablets is achieved by carefully applying layers of paint and then sanding and refining them so they appear not so much to cover the wood as to be a manifestation of its essential character. Sometimes Mikus applies twenty coats of paint to achieve the right degree of inner luminosity, and then in some pieces she waxes the surface to sustain its subtle glow (see pls. 41, 45). In many of the tablets painting and sanding are part of the creative process. Although the tablets achieve the patina of age, they also manifest the quality of a gracefully inflected whole. In other words, the tablets appear ancient and immaculate at the same time. Even where the materials have been

Fig. 9. Mikus, drawing of *Tablet 57,* 1963; graphite on paper, 5 × 3 3/4 inches

ripped and gouged, by using glue and paint Mikus creates a finished work that is thoroughly integrated. Her use of paint achieves a structural density that is integral to the meaning of her work.

A combination of primitivism and pure essence makes up the tablets, a combination that Mikus reveres in the early Italian art of Duccio and Giotto as well as in Byzantine icons. In those early paintings stylization serves as the vehicle for the spiritual. Because icons were made according to a set of established conventions, they appear to transcend the hands that made them. In the tablets Mikus finds a similar way of playing on stylization. In her words, the tablets exhibit "dulcet tensions, a simplicity, and a oneness achieved through nonaggression, acceptance, and understanding."[13] They continue the abstract expressionist manner of joining psychological and aesthetic needs in order to realize the self in universal terms, even though they avoid that style's excited brushwork and spontaneity in favor of allover, inflected monochromatic fields of unified pieces. In her notes Mikus wrote:

A need to use white only

A need for the jagged uneven but soft and gentle line

A need for the hard edged line gently curved

A need for the deep line straight as an arrow and strong and moving as the wind[14]

At another time she summarized her pursuit as an attempt to express herself: "What is painting but a need to express a search for something beautiful in life, some felt experience, something lacking and fulfilled in the work."[15]

The tablets depend on the formalist approach to art that was still dominant in the 1960s. That approach has been persuasively defined by Clement Greenberg in his brilliant, although far too prescriptive, dicta of the forties and the fifties.[16] In essays and critical reviews Greenberg describes modernist art coming to terms with its limits. He declares the aesthetic to be self-defining, self-limiting, and pure. His remarks below are apposite for Mikus's development since they are sympathetic to the leading role of painting and since they detail the approach she has personalized in the tablets, where she pushes painting to its limits:

The desire for "purity" works . . . to put an ever higher premium on sheer visibility and an ever lower one on the tactile and its associations, which include that of weight as well as of impermeability. One of the most fundamental and unifying emphases of the new common style is on the continuity and neutrality of a space that light alone inflects, without regard to the laws of gravity. There is an attempt to

overcome the distinctions between foreground and back-
ground; between occupied space and space at large; between
inside and outside; between up and down (many modernist
buildings, like many modernist paintings, would look almost
as well upside down or even on their sides). A related em-
phasis is on economy of physical substance, which manifests
itself in the pictorial tendency to reduce all matter to two
dimensions—to lines and surfaces that define or enclose
space but hardly occupy it. To render substance entirely
optical, and form, whether pictorial, sculptural or archi-
tectural, as an integral part of ambient space—this brings
anti-illusionism full circle. Instead of the illusion of things,
we are now offered the illusion of modalities: namely, that
matter is incorporeal, weightless and exists only optically like
a mirage. This kind of illusionism is stated in pictures whose
paint surfaces and enclosing rectangles seem to expand into
surrounding space; and in buildings that, apparently formed
of lines alone, seem woven into the air; but better yet in
Constructivist and quasi-Constructivist works of sculpture.[17]

Although the above passage might well describe Mikus's tablets,
Greenberg was not prepared to see his ideas carried out in her
manner and instead envisioned some of David Smith's almost two-
dimensional pieces as fulfilling his requirements for modernist art.
Whether Mikus was directly influenced by that section of
Greenberg's essay is immaterial to the discussion at hand.
Greenberg's thought then dominated the New York scene. It was
impossible for any aspiring avant-garde artist to avoid his ideas,
because they formed a basis for all advanced discussions of what
did or did not constitute modern art's rightful purview. The impor-
tance of Mikus's painted reliefs does not rest on her adherence to
Greenberg's principles, because those principles formed the basis
of such dissimilar schools as color field painting (which Greenberg
admired) and minimalism (which he detested). Her significance
depends on the merits of her individual works and their ability to
rise above modernist dogma to convey poetic insights into the
modern world and the human struggle to gain a place in it.

Mikus's friendship with Ad Reinhardt is informative, for he
appeared to follow most Greenbergian prescriptions while parody-
ing them and himself in works that are avant-garde as well as aca-
demic (fig. 10). His enlightening humor is a solid foundation for
his Zen approach to the world as well as a means for dealing with
the hegemony of Greenberg's thought. Reinhardt and Mikus be-
came friends in the 1960s, after she had already begun the white
tablets. In fact, even though he hated the color white, Reinhardt
was impressed enough with her work, which he saw in a group
show in 1961, to want to meet her.

Mikus shared with Reinhardt an interest in oriental art. In

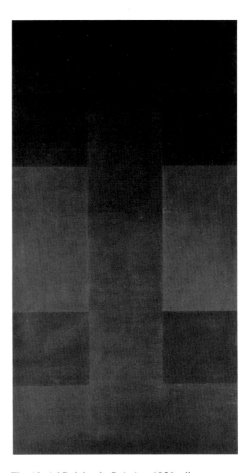

Fig. 10. Ad Reinhardt, *Painting*, 1956; oil on canvas,
80 1/4 × 43 1/8 inches; collection of the Yale
University Art Gallery; university purchase

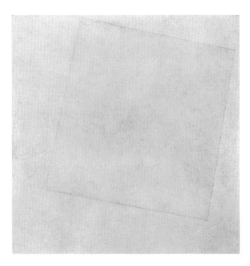

Fig. 11. Kasimir Malevich, *Suprematist Composition: White on White*, 1918; oil on canvas, 31 1/4 × 31 1/4 inches; collection of the Museum of Modern Art, New York City

1966 she studied Eastern art on her own and even became a member of Asia House. That year she received a Guggenheim fellowship in painting and thus had the time to pursue her interest. Her fascination with oriental art was no doubt anticipated by her early white, gray, and black tablets, which are a modernist manifestation of the same concern for essences that characterized the work of Chinese and Japanese monochromatic painters.

In 1967 Mikus went to the University of Denver to earn a Master of Arts degree in oriental art history. While there, she wrote a master's thesis that investigated the influence of Wang Wei on southern landscape painters. Wang Wei, an eighth-century painter who treated monochrome mainly from the standpoint of chiaroscuro and who discovered the principles that govern the fading of colors and forms in the distance, provided Mikus an opportunity to study the beginnings of monochromatic painting in the East, since he had initiated it. Significantly, her thesis contains statements sympathetic to formalism—statements that could, in fact, apply to her own work—such as her reference to the fact that "voiceless poetry is another name for paintings in China"[18] and her assessment of Wang Wei's contribution as an attempt "to simplify the objective images of the world and replace them with ideal images which, through his prolonged meditation, were free of nonessentials."[19] Similar to her own art, which veers away from the matte surfaces of modern painting and sculpture to achieve in white, gray, and black tablets luminous effects akin to atmosphere in nature, Mikus finds, "By the very nature of monochromatic painting the Chinese were led to express atmospheric perspective by means of tone value and harmony of shading instead of color."[20]

Black and white have special meaning for Mikus, who takes advantage of their everyday associations and at the same time goes beyond them. She has found that people regard the white tablets as difficult because they associate white with purity, absoluteness, and death.[21] She understands that resistance but thinks that the white tablets embody a sense of life and peace. "They have an almost childlike simplicity," she has noted, "which is all the more sophisticated for being that way."[22] White is quiet, serene, self-involved, and contained. While the white tablets are as mysterious as the black ones, they are not aggressive. The black tablets are oxymorons: they are shadows manifested as solid forms, reflections of themselves and their own mystery, threatening forms that bespeak an absence different from the absolute presence and intriguing absences of the white tablets. Because the white tablets suggest being through its absence, Mikus finds them challenging and intriguing and therefore returns to them periodically.

While the white tablets have an apparitional quality that is both evanescent and real, the black ones assertively proclaim themselves. Part of the special quality of the black tablets is due to the

inherent qualities of the color black, which is associated with darkness, power, and the unknown, and part is due to Mikus's recognition that these works need to be handled differently from the white and even the gray ones. Her meditations in black (see pls. 38, 41, 42, 44, 50, 54) are more assertive and hieratic than her other pieces. They, together with the few dark gray pieces, such as *Tablet 109* (pl. 37), employ an almost unrelenting repetition. They depend not so much on nuances as on the sheer quantity of boldly repeated simple shapes. *Tablet 154, 155, 156, 157, 158* (pl. 43), which can be displayed as one tablet or five, epitomizes that approach. Although beautiful, the gray tablets are neither as mysterious as the white ones nor as forceful and assertive as the black ones. The gray tablets tend to meld into the shadows they evoke rather than provide a screen for them, as do the whites, or serve as a foil for them, as do the blacks.

Mikus's white tablets belong to Western culture's fascination with white, which began with members of the late nineteenth-century aesthetic movement, including William Godwin, who reorganized James McNeill Whistler's house by clearing it of remnants of Victorian lugubriousness and by opting for pure white walls to show off collections of Japanese prints and blue and white porcelain. Charles Rennie Mackintosh, the Scottish architect, and his English-born designer-wife, Margaret Macdonald, are given credit for the first all-white room. In their Glasgow apartment, which they designed in 1900, they used white to unmask form and appear as pure presence. Almost two decades later white was used to transcend aesthetics in the interests of spirituality in Malevich's painting *Suprematist Composition: White on White* (fig. 11). This new understanding of purity even became a means for disciplining nature in Vita Sackville-West's all-white garden, which she developed at Sissinghurst Castle after World War II.

The aesthetics of white at times overwhelmed its spirituality in the international style of architecture embraced by the Museum of Modern Art in New York City, which adhered to the new practice of painting walls a pure, unadulterated white. In such spaces white works of art have come to be associated with the density of abstract thought and to be regarded as too complex to be easily divided into comprehensible parts. It is the abstractness and elusiveness of white that inform Jean Arp's surrealist sculpture (see fig. 12), Sol LeWitt's industrially fabricated minimalist permutations, and Mikus's tablets, giving them a distinctly modern look and yet making them appear resistant to innocent inquiries and casual investigations. They force viewers to take them seriously by regarding their contents as significant, though not easily understood.

Mikus began making paperfolds as a way of communicating the idea of the tablets to a larger audience. The first paperfold

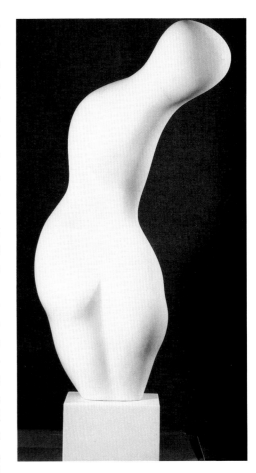

Fig. 12. Jean Arp, *Torse Gerbe* [Sheaf Torso], 1958; marble, 44 1/2 × 25 1/2 × 16 1/2 inches; Nathan Emery Coffin Collection of the Des Moines Art Center, Des Moines; Coffin Fine Arts Trust Fund

Fig. 13. Mikus, *White Paperfold Flyer,* 1963
(poster for a show at the Pace Gallery, Boston);
paper, 28 1/2 × 22 inches

(fig. 13) was made in 1963 as a flier for her first all-white show at the Pace Gallery in Boston. Before that exhibition Mikus had been accustomed to transforming index cards into folded reliefs (see pl. 68), which she used as sketches for her tablets. And in 1961 and 1962 she made several cardboard folds (see pl. 10) as a way of anticipating the effects of light and shadow in the tablets. The flier for the all-white show made her realize that paperfolds could be important works in their own right as well as an ongoing way of studying the light and shadow essential to the tablets. Similar to the tablets, the paperfolds allow Mikus to transform line into an actual gully capable of manifesting a real shadow. And also similar to the tablets, the paperfolds exist on the threshold of the imperceptible, demanding viewers' intense concentration as well as their time. In much the same manner as the tablets, these works slow down artistic perception to the real time involved in viewing actual paperfolds. They work in a similar manner to such new Italian films as Michelangelo Antonioni's *L'éclisse,* in which a minute of film time is a minute of real time. If viewers ask what they are perceiving, the answer is similar to the response given Zen initiates who wonder what one does after enlightenment: One does the same mundane things as before, but with a new understanding that transforms daily life into something wondrous.

"What I am trying to paint and say," Mikus once wrote, "is the feeling which is beneath all that is seen on the surface. I have found the more you look out the less you see. It seems only through a reverse that one can see. I make my own colors."[23] According to Zen, the enlightened see the everyday and the universal as one. That adventurous look into elements of the real world and into the ways that art partakes of the world's everyday aspects helps explain Mikus's assertion that her black, white, and gray works don't deny color, but accept it.[24] They accept color as a necessary concomitant of light and shadow, which, if given free play, will illuminate an object with all the colors of the spectrum. In Mikus's work the subtlety of color through light and shadow demands that observers be extraordinarily patient in order to discern it. The tablets and the paperfolds, then, require periods of rapt attention before revealing their contents. In the words of artist Norman Daly, they achieve maximum effect with minimum means.[25]

In the sixties and the early seventies museum personnel gave Mikus's work the concentrated study and appreciation it demanded. During that time her work was acquired by most major New York City museums, including the Museum of Modern Art, the Whitney Museum of American Art, the Brooklyn Museum, the New York University Collection, and the Newark Museum, as well as prestigious public collections throughout the United States, including on the West Coast the Los Angeles County Museum of Art and the Norton Simon Museum in Pasadena, California. Her work in the 1960s pulled together different traditions into unified wholes

that indicated the possibility of harmony and understanding. The tablets join Greenberg's formalism with assemblage and combine elements of the real with universal essences. Their construction makes them appear to be inscribed with experience, but their pristine painted surfaces look as if they have been left blank to serve as images of renewal. Those seeming contradictions of reality and illusion, inscription and blankness, and presence and absence give the tablets their special power and help explain why they became such fitting images for the sixties, a decade when people were searching for authenticity and renewal.

In late 1968, after enjoying critical acclaim for her tablets, Mikus dramatically changed direction by creating a neo-expressionist style that extolls simplicity and directness (see pls. 55–58). Her neo-expressionist work began in December after she had finished thirty-two editions of prints at the Tamarind Lithography Workshop (see pls. 66, 86–90). The concentration required for undertaking those prints coupled with their success may have encouraged her to undertake new experiments. At the end of the sixties many artists, including Alfred Leslie and Philip Guston, were moving in radically new directions. The changes represent a reassessment of style and its traditional limits. These artists began to feel that the high modernism of Clement Greenberg had run its course, and they realized that painters might approach art with the freedom of Picasso; that is, they could work in more than one style rather than limit themselves to the strictures of a single governing image, as occurs in the art of Piet Mondrian, Barnett Newman, and Mark Rothko.

Opting for the new freedom, Mikus began making stick drawings, which later developed into neo-expressionist paintings. Although her boats, planes, trains, and dragons (see pls. 55–58) might appear far removed from the subtly nuanced, radiating surfaces of her tablets, both groups of work actually derive from Zen attitudes. While the tablets de-emphasize subject matter and require a viewer to gradually approach real light and shadows, the neo-expressionist works emphasize subject matter and elicit instantaneous recognition. In the latter pieces Mikus cultivated an outgoing attitude that revels in spontaneity and simplicity. The works are intended to shock viewers into coming to terms with life and seeing it with directness and humor. The neo-expressionist paintings draw on a tradition of appreciation for children's art that is evident in German expressionism and also in the highly cerebral as well as playful works of Paul Klee. In addition Mikus's neo-expressionist style is similar to Jean Dubuffet's in its interest in the art of people with special problems. In the early 1960s Mikus taught painting to elderly immigrants in Brooklyn who had little or no formal education. She was fascinated with the freshness and directness of their forms. The experience no doubt had an impact on her later neo-expressionist works.

Although in the 1960s Mikus became part of the then-small coterie of avant-garde artists living in New York and was friends with Louise Nevelson and Andy Warhol, among others, she regarded her studio as a private laboratory and her work as intensive research into art's means and essence. With her neo-expressionist work she moved from the cloistered atmosphere of the Pace Gallery and showed first with the Grand Central Moderns Gallery before becoming part of Ivan Karp's new gallery, the OK Harris Gallery. The neo-expressionist work was probably stimulated and sustained by contacts made during her four years in England (1973–77).

When Mikus moved in the late 1970s, from London to New York City and then to Ithaca, New York, where she teaches art at Cornell University, her work also changed. Although she continued making neo-expressionist works, she resumed, after a hiatus of twelve years, the paperfolds. In 1985 she turned again to the tablets, this time in oil on canvas. The new works reflect her changed environment and her more contemplative life-style: she now looks within in order to look without. They reflect her current thinking as well as her seclusion in a Greek revival church that she has converted into a combined studio and living space. Mikus's change from the tablets to the neo-expressionist paintings and her subsequent return to the tablets in the 1980s is akin to Charles Burchfield's move from early fanciful and highly symbolic watercolors in the 1920s to paintings of the American scene and his return several decades later to the romantic works of his youth.

In the newest tablets Mikus creates an imbricated, textured surface (see pl. 59) that indicates a continued preference for subtly oscillating planes that articulate mostly monochromatic fields of color. The new works invoke the earlier tablets and the grand tradition of modernism. In the new pieces, however, an elegiac tone differs markedly from the luminous, smooth surfaces of the iconic early tablets. Instead of reflecting light, recent tablets absorb it (see pl. 62). They bespeak the grand tradition of oil painting that goes back to the late style of Titian, who recognized the ability of oil paint to suggest through insinuation and to describe without ever totally immobilizing form. In the recent tablets (see pls. 59, 60), then, Mikus pays homage to oil painting. She joins the two in formalist works in which subtlety of color at the service of a monochromatic format plays an important role. In invoking art's tradition, Mikus's new paintings (see pls. 63–65) at times call to mind the coruscations of paint making up Turner's atmospheres and the scumbled surfaces of Monet's almost abstract water lilies. She uses those ephemeral conventions to achieve the seemingly opposite effect of roughly finished old brick walls and thus metaphorically posits in a new way the Zen conundrum of how to surmount the walls built by the rational mind to achieve atmospheric freedom.

NOTES

1. Thomas Hine, *Populuxe* (New York: Alfred A. Knopf, 1987).

2. William C. Seitz, *The Art of Assemblage* (New York: Museum of Modern Art, 1961), provided the most in-depth coverage of this artistic approach, which was beginning to lose its hegemony in the early 1960s.

3. Rick Fields, *How the Swans Came to the Lake: A Narrative History of Buddhism in America* (Boston: Shambhala, 1986).

4. Barbara Rose, "A B C Art," *Art in America* 53 (October–November 1965): 57–69. This essay, one of the first to deal with minimalism, serves the important function of using the special vocabulary of minimalists Carl Andre, Donald Judd, and Robert Morris, who were Rose's friends, and Frank Stella, who was her husband. Such terms as *boring, vacant,* and *empty,* which might seem harsh criticism of their art, were in fact accepted by the artists and their coterie as words that described new, radical, and important aesthetic concerns.

5. Eleanore Mikus, conversation with author, November 1988.

6. Ibid.

7. Eleanore Mikus, notes, 1960s. These notes are part of the artist's archives in her studio in Groton, New York.

8. Ibid.

9. Mikus, conversation.

10. Eleanore Mikus, letter to author, August 1989.

11. Mikus, conversation.

12. Ibid.

13. Mikus, notes.

14. Ibid.

15. Ibid.

16. Clement Greenberg's essays, originally published in *Partisan Review,* the *Nation, Commentary, Arts, Art News,* and the *New Leader,* were selectively reworked for *Art and Culture* (Boston: Beacon Press, 1961).

17. Greenberg, *Art and Culture,* 144–45. An earlier version of this quotation first appeared in the essay "The New Sculpture," *Nation,* 11 June 1949. Elizabeth Murray is now working in the tradition of pushing painting to its formal limits that Mikus, Frank Stella, and Sven Lukin, among others, epitomized in the 1960s.

18. Eleanore Mikus, "The Influence of Wang Wei on Southern Landscape Painters with Historical Background on the Technique and Philosophy of Chinese Painting" (M.A. thesis, University of Denver, 1967), 4.

19. Ibid., 5.

20. Ibid., 6.

21. Mikus, conversation.

22. Mikus, notes.

23. Ibid.

24. Mikus, conversation.

25. Ibid. Daly and Mikus both taught art at Cornell University in the late 1970s and early 1980s. Daly is semiretired; Mikus is still a member of the Department of Art.

ELEANORE MIKUS

MINIMAL WORKS ON WOOD, PAPER, AND CARDBOARD

JUDITH BERNSTOCK

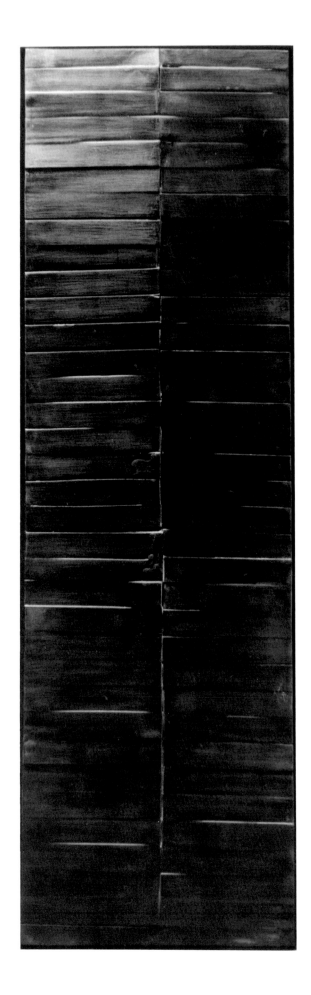

Tablet 154, 1966 (see pl. 43)
Black epoxy on wood
88 × 28 1/2 inches

ELEANORE MIKUS considers the evolution of simple forms into a perfected and unified whole to be fundamental to the creation of her minimal works of art: "Starting with something small, just a line, and making something big—that's what it's all about. From just a small line, a fold, you can make the rest of your life. That's what I've done."[1]

Mikus's works in various media manifest an underlying uniformity that is not at odds with her continual desire to experiment, change, and perfect. She has striven to improve her means and to make them capable of registering even the subtlest expression.

In 1959 Mikus departed from an abstract expressionist mode of painting, which had become too predictable, and began to work in a more minimalist vein, combining glue and stamp hinges on wooden boards. *Window I* (pl. 7) demonstrates her increasing tendency toward geometric abstraction and her evocation of a sense of peace through a harmonious balance of horizontally aligned forms and a unifying rich texture. Thirty years after its creation she reflected on *Window I* and some of her lifelong artistic goals that were first revealed in it: "I like the movement here, the kinesthetic feeling, the subtlety, and the formal simplicity. I try to create what I feel and strive for basic form and color." The mood evoked by her art is invariably and intentionally peaceful—"quiet, not aggressive."

In an untitled work from 1960 (pl. 6), a work with dynamically interacting curvilinear and jagged lines, Mikus combined

Fig. 14. Mikus, *Mountain Blue*, 1956; oil on canvas, 24 × 36 inches

rabbit-skin glue and staples on wood. This relief represents a major advance over her 1956 painting *Mountain Blue* (fig. 14) and her 1957 painting *Abstract Cantata* (fig. 15) in its greater sense of transformation of individual elements. Whereas paint necessarily remained paint in her earlier works, everyday objects such as staples and loose-leaf reinforcements acquire new artistic identities in her reliefs. Their metamorphoses seem to be part of a natural process: glue spreads and cracks in random patterns, enveloping staples and reinforcements in its meandering linear webs to create a poetic mood of unity. In her transformations of humble raw materials into balanced designs, she aims to evoke "a feeling of peace, oneness, solidity."

Mikus traces her predilection for wood back to her maternal grandfather, who was a carpenter. Seeing in him and in her art a commitment to fundamentals, she says: "I'd manipulate forms, giving only the essentials. You see the horizontal lines here. I like wood grain. I like wood, painted or otherwise. It's like the wear and tear of life." Rough lines of natural wood grain harmonize with sharp edges of mechanically cut boards in *Brown/Grey/White*, 1960 (pl. 5).

Like Henri Matisse, Mikus plays with the traditional illusionistic window view into space, especially in her oil paintings of 1959–61. A concern with spatial relationships—internal and external, near and far—is evident in her increasingly three-dimensional reliefs from that period, beginning in 1959 with the illusionistic, two-dimensional *Window I* and culminating in 1961 with her first cardboard fold (pl. 10). In the later work torn rectangular pieces of corrugated board resemble a facade of windowpanes even though they are ordered loosely along a grid and glued onto a wooden board. The individual pieces of cardboard seem recessed behind the raised borders—the window frames, which are shared by adjacent rectangles (pl. 16). The whole is animated and

Fig. 15. Mikus, *Abstract Cantata,* 1957; oil on Masonite, 48 × 48 inches; collection of the Denver University School of Art, Denver

united by a subtle interplay of horizontal and vertical lines: gentle grooves in the wood are complemented by strongly contrasting light and dark accents formed by raised rims and cast shadows. The vitality and diversity of roughly torn and cut edges are contained by the sharp contour of the outer frame and by the white paint uniformly enveloping the whole. Mikus expressed the same ideas through similar means, but on a smaller scale, in holiday cards that she began to make for a select group of people by folding the centers of the cards.

During the summer of 1963 Mikus transformed simple index cards into obdurate and permanent surfaces of works of art, as in *Relief 16* (pl. 68), by folding, painting, and mounting the cards on board. A variety of tones resulted from modulating the density of the paint on the surfaces. She created cardboard folds in the early 1960s by recombining torn pieces of cardboard, treating them with flat alkyd paint, and then sanding them smooth. As critic Barbara Rose pointed out in 1963, the even surfaces punctuated by lines are like walls with cracks. Fascinated by linear movements, Mikus even delighted in the cracks on subway walls that she saw when commuting to her teaching job in Brooklyn in the 1960s.

Paperfolds began to become increasingly important to Mikus with her designs of fliers for her exhibitions at the Pace Gallery in New York City. *White Paperfold Flyer* (fig. 13) dates from 1963, and *Grey Paperfold Flyer* (fig. 16), from 1964. Shortly thereafter her fliers evolved into paperfolds on a grand scale. As a result of a technique she perfected in about 1980 (see pls. 73–83) that involves folding, ironing, and pressing out Inomachi paper, a parchmentlike paper made from the fibers of the *kozo* tree and the *mitsumata* tree, Mikus's recent paperfolds (see pls. 84, 85) resemble richly textured, chiaroscuro drawings composed of innumerable delicate, crosshatched lines. Mikus says: "An equilibrium in nuances and movement of lines must underlie a paperfold. Only then can a universal harmony be finally aesthetically achieved." Evanescent effects appear frozen in time in serigraph prints made in 1964 of individual paperfolds, such as *White Serigraph Paperfold #2* (pl. 70).

Mikus's experimentation with graphics began in 1968, when she was invited to the Tamarind Lithography Workshop, a nonprofit organization founded in 1960 to train master printers and bring them together with mature artists. Mikus's use of paper was an innovation at Tamarind: about half of her color lithographs (see pls. 86, 88, 90) she carefully folded at regular intervals with a Japanese ivory bookbinder's tool—a tool that she used only in folding the prints, not in creating her paperfolds. The creases catch light and cast subtle shadows on the work, creating an interplay between natural light and image. The mood evoked in those prints varies greatly. A statement regarding Mikus's Tamarind fellowship says:

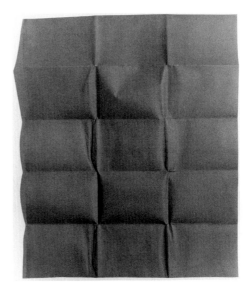

Fig. 16. Mikus, *Grey Paperfold Flyer,* 1964 (poster for a show at the Pace Gallery, New York City); paper, 25 × 21 inches

"A poetic yet strong use of line represents 'motions of feelings' in Eleanore Mikus's thirty-six lithographs created at Tamarind. This elemental imagery, modulated in color and texture, suggests to Mikus the feeling beneath all that is seen on the surface."

In some works, as in *Tablet Litho 2* (pl. 90), vibrant designs emerge from strong value contrasts, and dancing patterns result from lines that come forward and recede. In other works, including *Tablet Litho 3* (pl. 86), in which barely perceptible folds appear as evanescent white lines against black backgrounds, an extraterrestrial domain is evoked. In still other prints, which are devoid of ink, such as *Tablet Litho 18* (pl. 88), white lines seen against white backgrounds resemble intricately folded parchment. *Tablet Litho 18* is formed of ten thousand folds. A historian of Chinese art later informed Mikus that the number ten thousand symbolizes endlessness to the Chinese. The oriental overtones of *Tablet Litho 18* are not surprising when one realizes that Mikus first came in contact with paperfolds other than her own in the 1960s, when she saw at Asia House in New York City a work created by an artist of the Tang period.

Whether working with wood, cardboard, or paper, Mikus focuses on the changing quality of line as it widens, narrows, and participates in a play of kinesthetic movements of light and shadow on surfaces. Whereas a paperfold may take only two months' work, and a painting may require two years', Mikus approaches both in a meditative manner. She compares her manipulation of line to a painter's handling of a brush and therefore likens herself to Rembrandt and the abstract expressionist painters. She maintains that she achieves effects analogous to those of a painted line by tearing cardboard, precisely folding paper, crisply incising a line with a metal tool, or bluntly carving a groove in paper with a wooden object, thereby "remolding the elements to make them obey the rhythm of a deep-rooted sense of design as in drawing or painting."

Mikus generally prefers to use white paint in her minimal works, for she believes that it appears classical under cast light: "I like white. Although it's frightening to some people, cold and

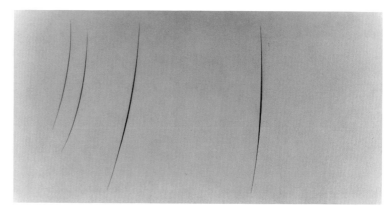

Fig. 17. Lucio Fontana, *Spatial Concept Expectations 59 T 133,* 1959; water-based paint on canvas, 49 5/8 × 98 3/4 inches; collection of the Solomon R. Guggenheim Museum, New York City; gift of Teresita Fontana

empty, and reminds others of death, it is also pure, moving, quiet, and peaceful. I simplify all elements to their essentials, to what is purely expressive."

The evolution of Eleanore Mikus's minimal work is in tune with artistic developments in Europe and the United States in the fifties, sixties, and seventies. Her work shares affinities with that of other artists who also aspired to a purified, aesthetic realm, including Ellsworth Kelly, who began in 1950 to create white wood reliefs in which light and shadow evoke special moods and strips of white cardboard glued onto wood panels make abstract patterns and also simulate building facades in Paris, where he was then living. In their spatial relationships Mikus's works are similar to Lucio Fontana's slit and perforated paintings of the 1950s and 1960s. In particular Fontana's lines in *Spatial Concept Expectations 59 T 133* (fig. 17) suggest an architectural and sculptural aura akin to Mikus's *Relief 19*, 1964 (pl. 69).

Mikus's affinity with Louise Nevelson, a fellow exhibitor at the Pace Gallery, is evident in the gridlike structure that underlies the work of both artists in the 1960s. Nevelson's monochromatic wooden walls composed of small individual boxes are akin to Mikus's walls of paper and cardboard rectangles. Both have an elegance and grace that derive partly from the precision with which units are randomly assembled.

Mikus describes the work of Ben Nicholson as "beautiful, classical, and rich in texture" and esteems it highly among the creations of earlier twentieth-century masters. Nicholson attempted to recreate the essence of classical Greece through abstract form and color. In his reliefs dating from the 1930s and 1940s (see fig. 3) he hoped to express a poetic idea through a universal language of basic geometric shapes. He sought an abstract art that would make direct contact with the viewer and that would be comprehensible to those who did not erect barriers against it.

The romantic side of Mikus's nature, evident in her unusual sensibility and her aspiration toward a perfect realm in her art, helps explain her attraction to the work of such artists as Jean-Auguste-Dominique Ingres, Albert Pinkham Ryder, Paul Klee, Kasimir Malevich, and Piet Mondrian. Not only are her black paperfold drawings (1981–82) reminiscent of Ryder's moody, dark paintings with a haunting light (fig. 18), but also her obsessive search for sensuous beauty manifested in rich surfaces and rhythmic, harmonious designs recall Ryder. Her admiration for artists who achieve subtle textures explains her enthusiastic appreciation of Ingres's finely nuanced drawings (fig. 19), which she prefers to sketches by Hilaire-Germaine-Edgar Degas. The gentle modulations of line, light, and shadow characteristic of Ingres's delicate portraits find their modern abstract counterparts in Mikus's paperfolds (see pls. 78, 82) and *Collage Fold #4* (pl. 67).

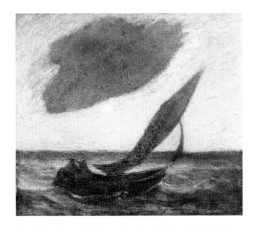

Fig. 18. Albert Pinkham Ryder (1847–1917), *Under a Cloud*, n.d.; oil on canvas, 20 × 24 inches; collection of the Metropolitan Museum of Art, New York City; gift of Alice E. van Order in memory of her husband, Dr. T. Durland van Order

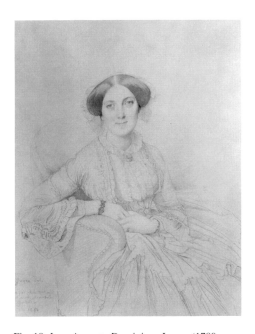

Fig. 19. Jean-Auguste-Dominique Ingres (1780–1867), *Madame Felix Gallois*, n.d.; graphite and watercolor on wove paper, 13 1/2 × 10 1/2 inches; Robert Lehman Collection of the Metropolitan Museum of Art, New York City

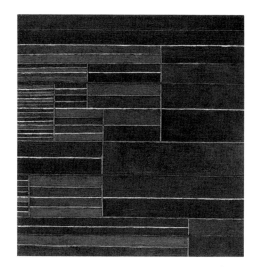

Fig. 20. Paul Klee, *In the Current Six Thresholds,*
1929; oil and tempera on canvas, 17 1/8 × 17 1/8
inches; collection of the Solomon R. Guggenheim
Museum, New York City

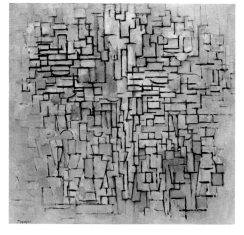

Fig. 21. Piet Mondrian, *Composition VII,* 1913; oil
on canvas, 41 1/8 × 44 3/4 inches; collection of the
Solomon R. Guggenheim Museum, New York City

Mikus also has a long-standing interest in the work of Paul Klee. She credits him with helping her realize that large works derive from small, insignificant components. On a purely formal level, the complex patterns of her paperfolds evoke memories of the intricate designs in several of Klee's paintings, including *Ad Parnassum,* 1932, and *In the Current Six Thresholds,* 1929 (fig. 20). She recognized in Klee a kindred spirit, an artist similarly inspired by oriental mysticism and also concerned with geometry as well as organic growth.

Mikus's use of geometric design posits a specific aesthetic experience that may act as a stimulus to meditation. Such spiritually motivated geometric abstractions call to mind Malevich's dynamic organization of white rectangles and his discovery of spiritual essence in the form of a white square (fig. 11). Clearly the closest precedent for Mikus's concern with purity of line and color coupled with kinesthetic movements across a painting's surface is the work of Piet Mondrian (fig. 21), who attempted to use pure means to express reality through an equilibrium of dynamic movements of form and color.

After an exploration of figurative, neo-expressionist painting beginning in 1969 (see pls. 55–58), Mikus returned in the early 1980s to nonobjective works in order "to pull something out of painting that is on a higher order, something more philosophical and much more humane." Eleanore Mikus regards simplicity and order as the most crucial elements in a successful work of art. She achieves simplicity by eliminating all that is superficial and superfluous and achieves order through geometry and design.

What Mikus said of her work in 1971 is true today as well:

> In my painting I have pursued my conviction that form
> without substance cannot truly express significance. External
> formal constructs such as line, form, and color cannot in
> themselves be an expression of the creative impulse but
> must be deeply rooted in the individual. By "substance" I
> am speaking of the dynamic inner flow of feeling, thought,
> and imagination which every true artist struggles to discover,
> experience, and express. It is to the synthesis of all these
> elements in my work that I devote my concentration and
> energy.

1. All the quotations from Eleanore Mikus are based on an interview with the author on 8 January 1989.

PART I

EARLY PAINTINGS AND
TABLET PAINTINGS

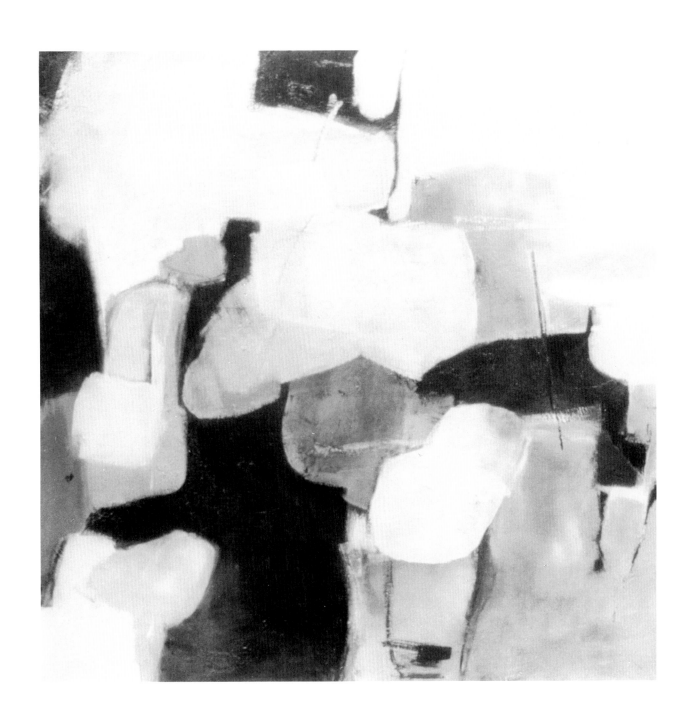

1. *Untitled,* 1958
 Oil on Masonite
 48 × 48 inches
 Collection of Richard F. Burns, Jr.,
 West Bloomsfield, Michigan;
 formerly collection of Bertha Mikus

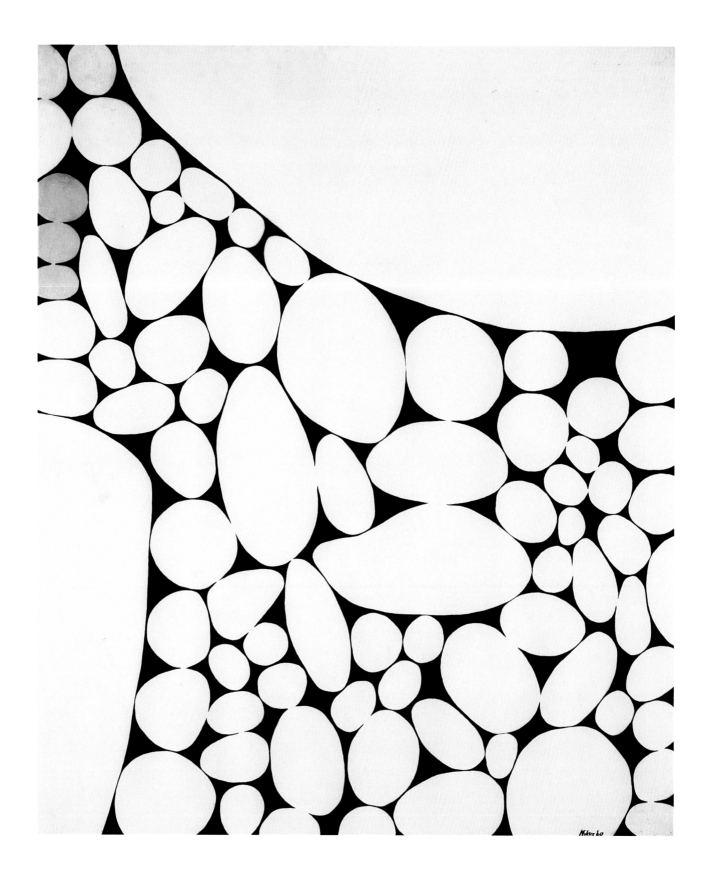

2. *Garden*, 1959
 Oil on canvas
 60 × 48 inches

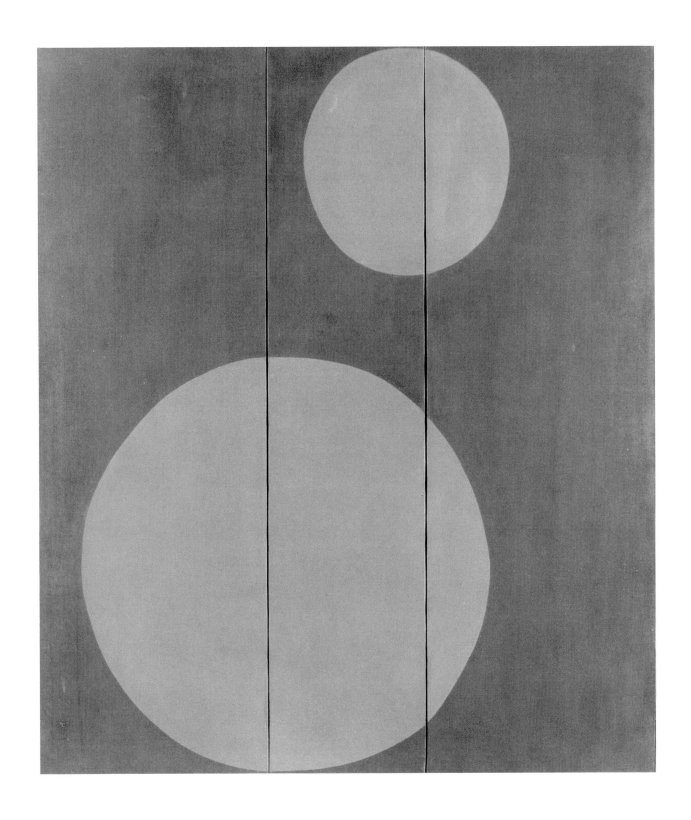

3. *3 + 5*, 1959
 Oil on canvas
 36 × 32 inches

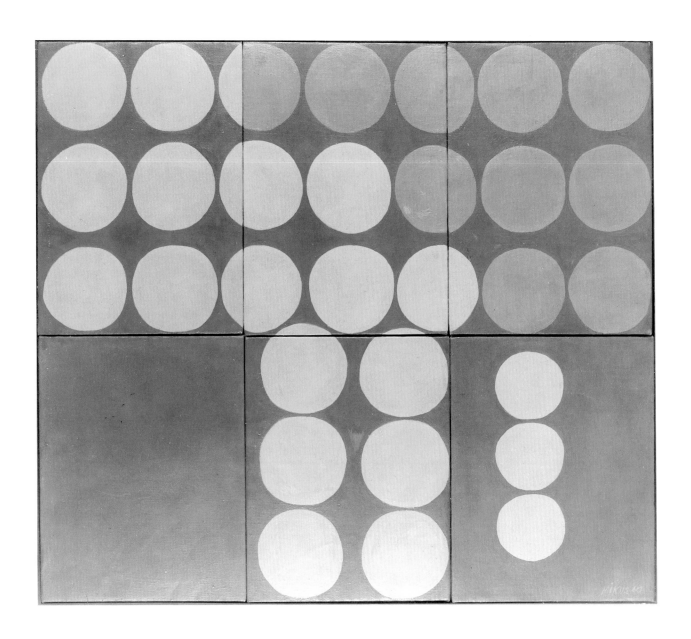

4. *Ortho*, 1960
 Oil on canvas
 21 1/2 × 24 1/2 inches
 Private collection

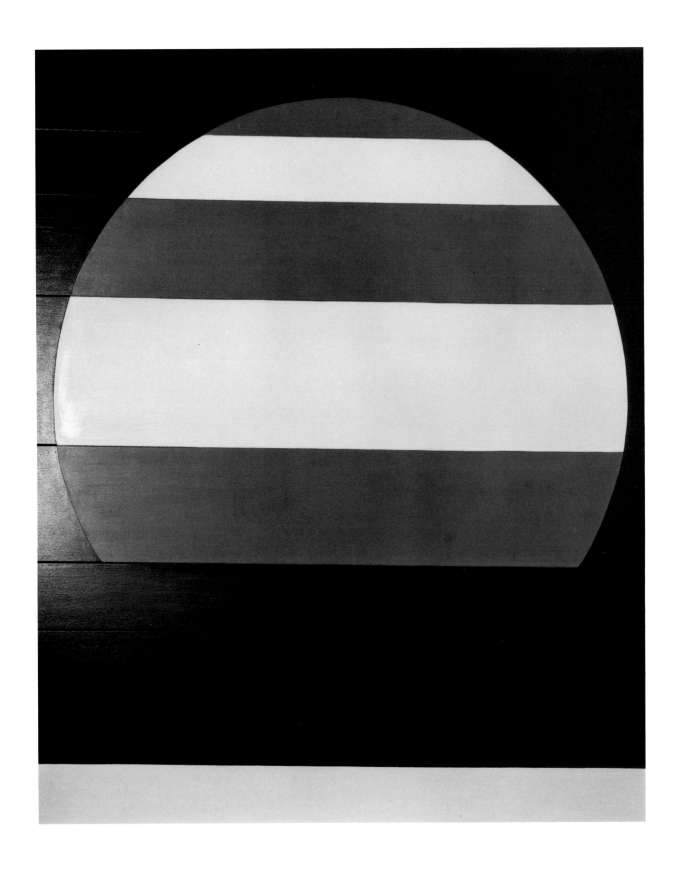

5. *Brown/Grey/White*, 1960
 Oil on grooved plywood
 60 × 48 inches
 Private collection

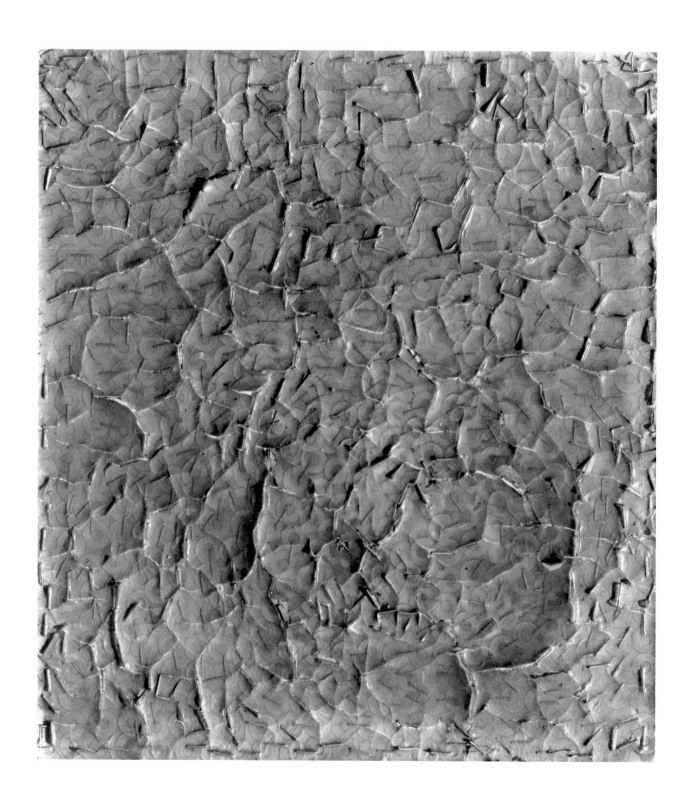

6. *Untitled*, 1960
 Loose-leaf reinforcements, rabbit-
 skin glue, and staples on wood
 14 × 13 inches

44

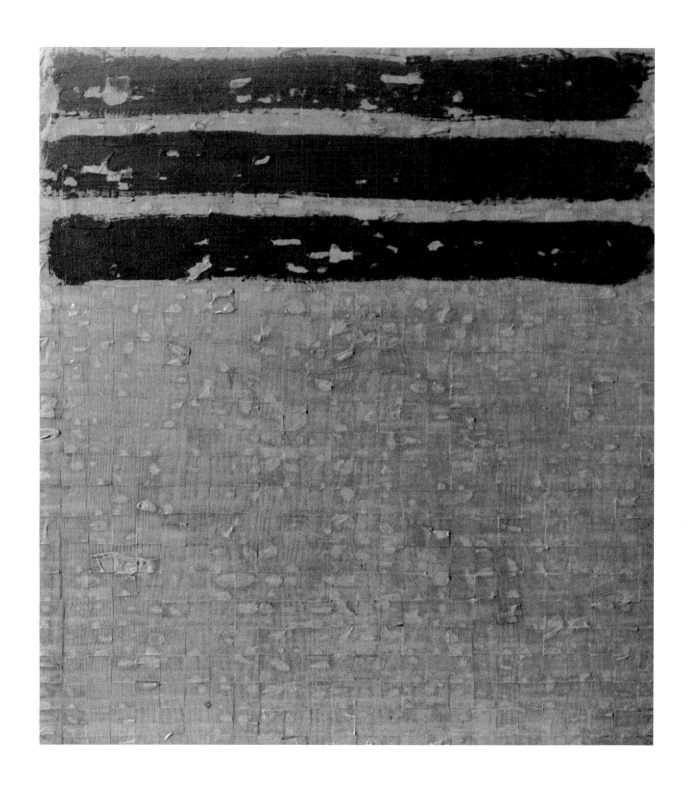

7. *Window I,* 1960
 Stamp hinges and glue on wood
 15 1/4 × 14 inches

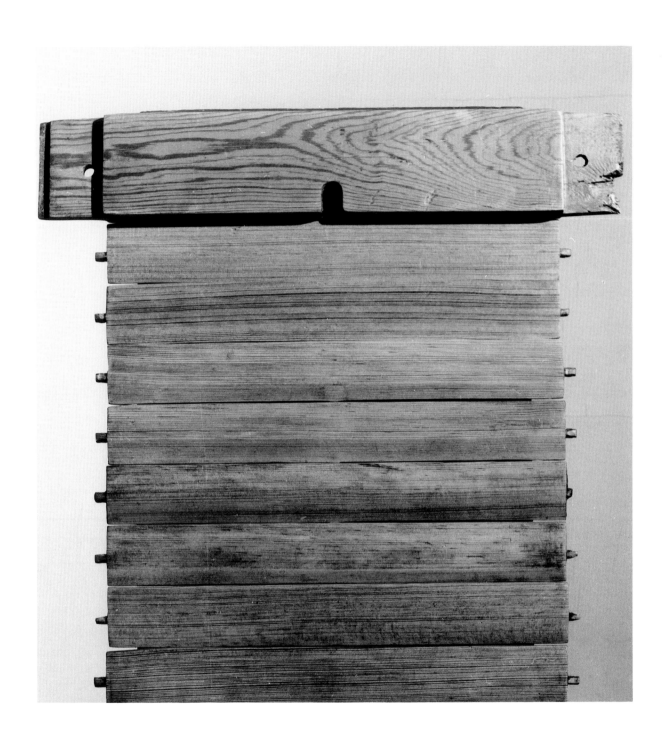

8. *Untitled*, 1960
 Wood
 17 1/2 × 17 inches

46

9. *Mark III*, 1961
 Oil on grooved plywood
 60 × 48 inches

10. *Cardboard Relief Fold*, 1961
 Oil on corrugated cardboard
 12 × 14 inches

48

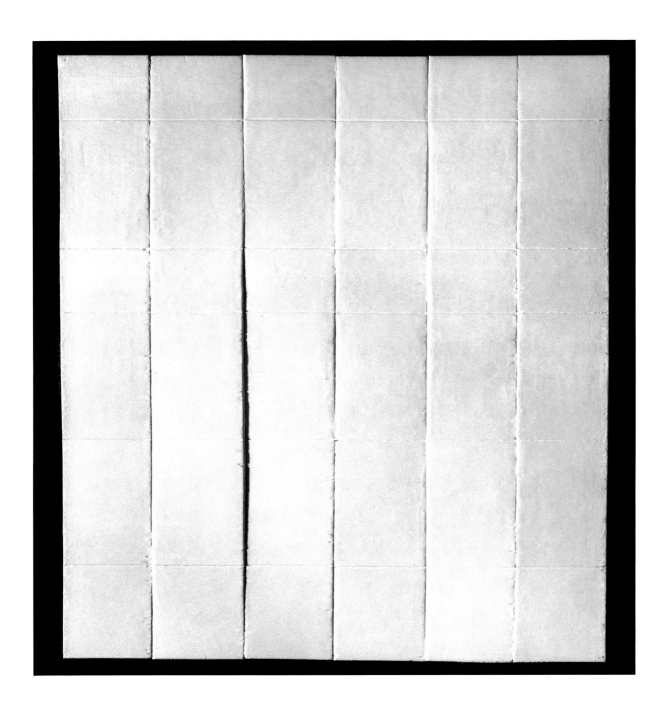

11. *Tablet 1*, 1961
 White oil on grooved plywood
 42 × 42 inches

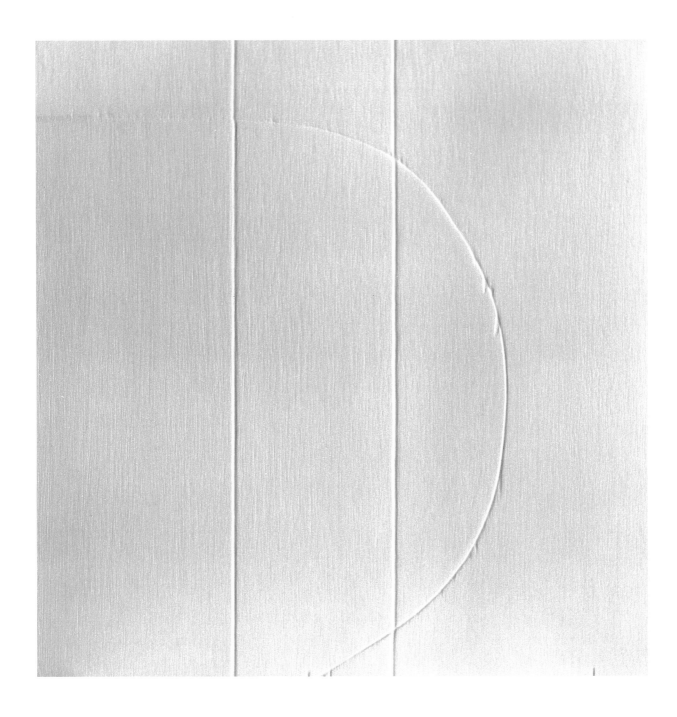

12. *Tablet 2*, 1961
 White acrylic on grooved plywood
 38 1/4 × 22 3/4 inches

13. *Tablet 5*, 1962
 White acrylic on grooved plywood
 24 × 24 inches
 Private collection

14. *Tablet 6*, 1962
 White acrylic on grooved plywood
 48 × 36 inches
 Private collection

15. *Tablet 10*, 1962
 Flat enamel on wood
 4 3/4 × 4 inches

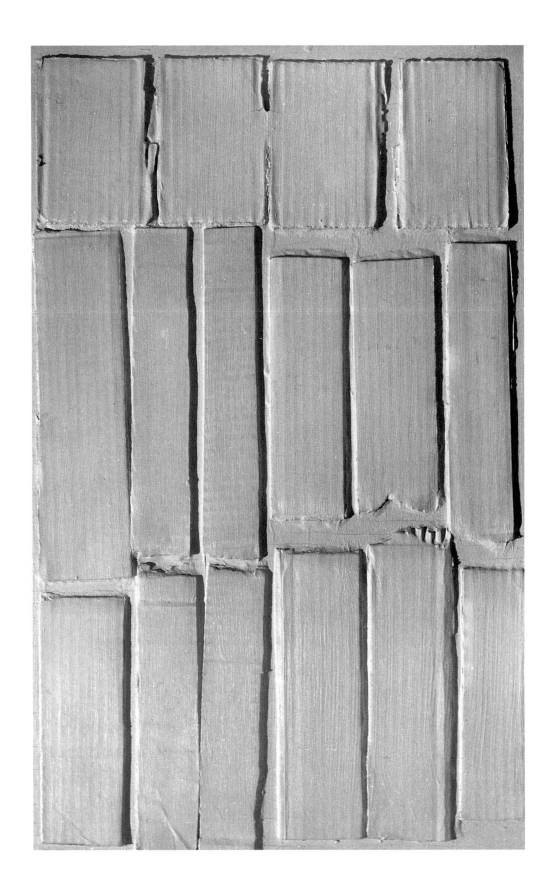

16. *White Relief,* 1962
 White oil on corrugated cardboard
 glued to wood
 24 × 15 1/2 inches

17. *Tablet 20,* 1963
 White acrylic on grooved plywood
 48 × 48 inches
 Collection of the Birmingham Museum
 of Art, Birmingham, Alabama;
 gift of Silvia Pizitz

18. *Tablet 27,* 1963
 White flat enamel on wood
 3 1/2 × 2 1/4 inches

19. *Tablet 31*, 1963
 White acrylic on grooved plywood
 23 3/4 × 17 3/4 inches

20. *Tablet 32*, 1963, 1966, 1988
 White enamel on grooved plywood
 83 1/2 × 63 3/4 inches

21. *Tablet 49*, 1963
 White flat enamel on wood
 48 × 30 1/2 inches
 Aldrich Collection, courtesy of the Aldrich Museum
 of Contemporary Art, Ridgefield, Connecticut;
 museum purchase

22. *Tablet 51*, 1963
 White flat enamel on wood
 12 × 12 inches
 Collection of Richard Witter,
 New York City

23. *Tablet 55,* 1963, 1966, 1980
 White epoxy on wood
 72 × 57 3/4 inches
 Private collection

24. *Tablet 56,* 1963, 1966
 White epoxy on Masonite
 71 3/4 × 47 1/2 inches

25. *Tablet 58,* 1963
 White enamel on composition board
 88 × 59 3/4 inches
 Collection of the Whitney Museum of
 American Art, New York City;
 gift of Fred Mueller

26. *Tablet 61*, 1963, 1966
White epoxy on wood
9 1/4 × 6 1/2 inches

27. *Tablet 62*, 1963
White epoxy on wood
95 1/2 × 47 7/8 inches
Collection of the Brooklyn Museum,
Brooklyn, New York; anonymous gift

28. *Tablet 66*, 1963–64
 White flat enamel on Masonite
 60 1/8 × 36 inches
 Private collection

29. *Tablet 74*, 1964
 White oil on wood
 12 × 11 inches

30. *Tablet 80*, 1964
 White epoxy on wood
 29 1/4 × 28 inches
 Private collection

31. *Tablet 82*, 1964
 Gray acrylic on wood
 56 1/2 × 35 1/4 inches
 Collection of the Brooklyn
 Museum, Brooklyn, New York;
 anonymous gift

32. *Tablet 84*, 1964
White acrylic on composition board
51 1/2 × 36 inches
Collection of the Museum of Modern Art,
New York City; gift of Louise Nevelson

33. *Tablet 86*, 1964, 1966
White epoxy on wood
12 × 11 3/4 inches

34. *Tablet 88*, 1964
White oil on wood
6 1/8 × 6 inches

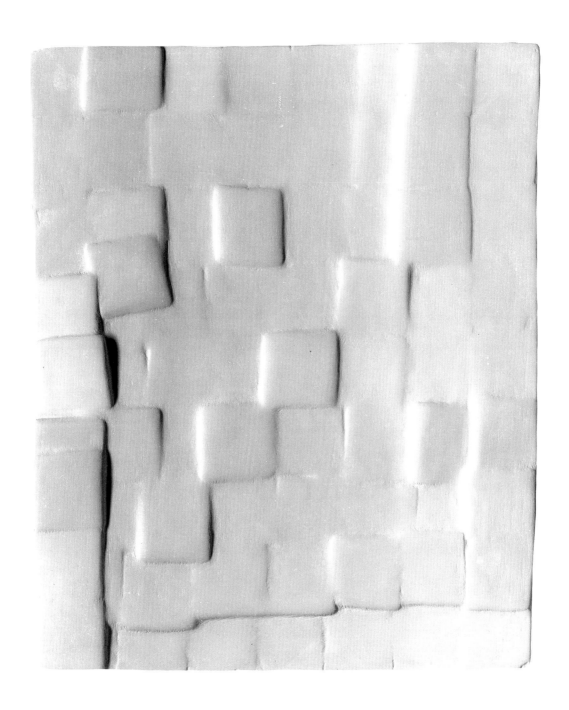

35. *Tablet 92*, 1964
 White oil on wood
 15 × 12 1/2 inches

36. *Tablet 98*, 1964
 Gray acrylic on wood
 44 3/4 × 31 1/4 inches

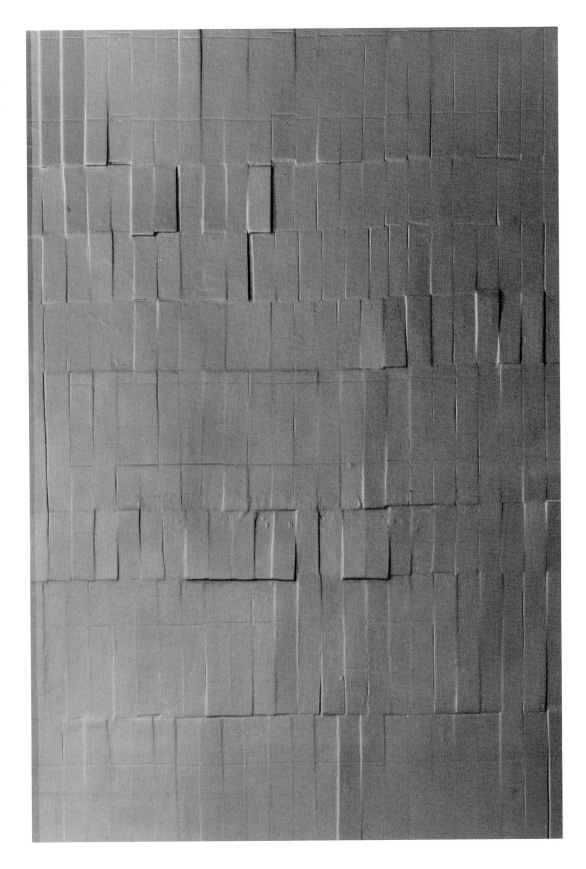

37. *Tablet 109*, 1964
 Gray acrylic on wood
 71 1/4 × 48 inches
 Collection of the Museum of Fine Arts,
 Springfield, Massachusetts; gift of the Pace Gallery

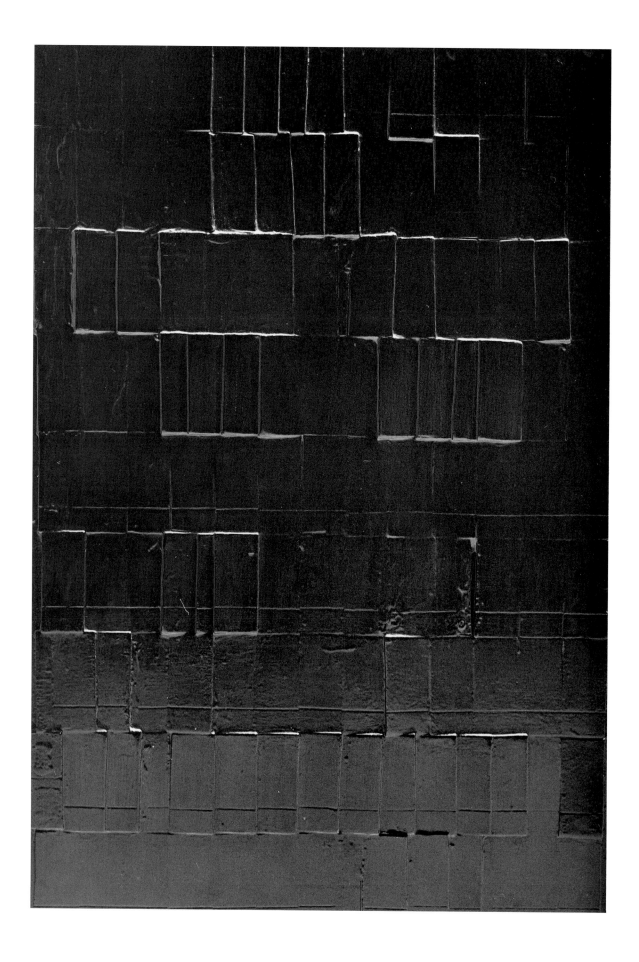

76

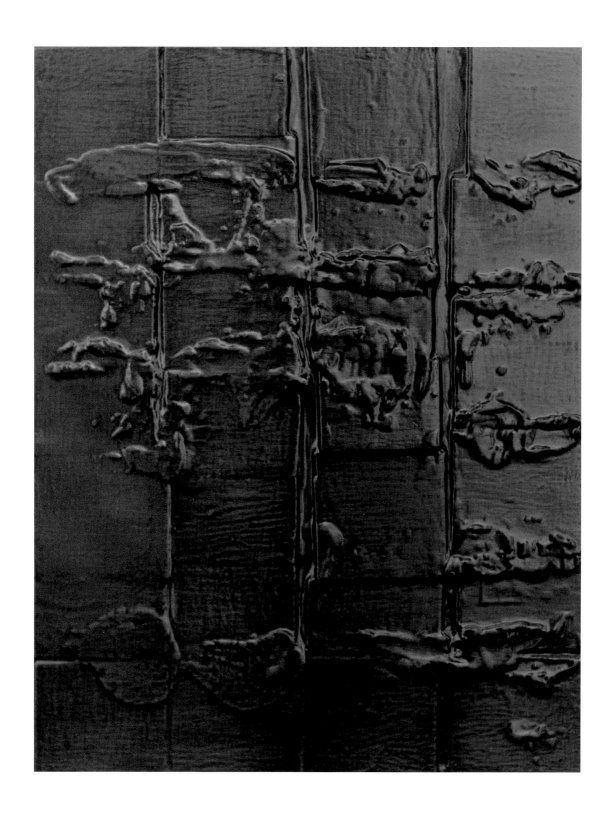

38. *Tablet 111,* 1964–66
 Black epoxy on wood
 72 × 48 inches
 Collection of the Palm
 Springs Desert Museum,
 Palm Springs, California;
 gift of Dorothy J. and
 Benjamin B. Smith

39. *Tablet 113,* 1964, 1968
 Black epoxy on wood
 25 × 19 1/2 inches

40. *Tablet 120,* 1964
 Gray acrylic on wood
 27 1/4 × 26 1/4 inches
 Collection of the Pace
 Gallery, New York City

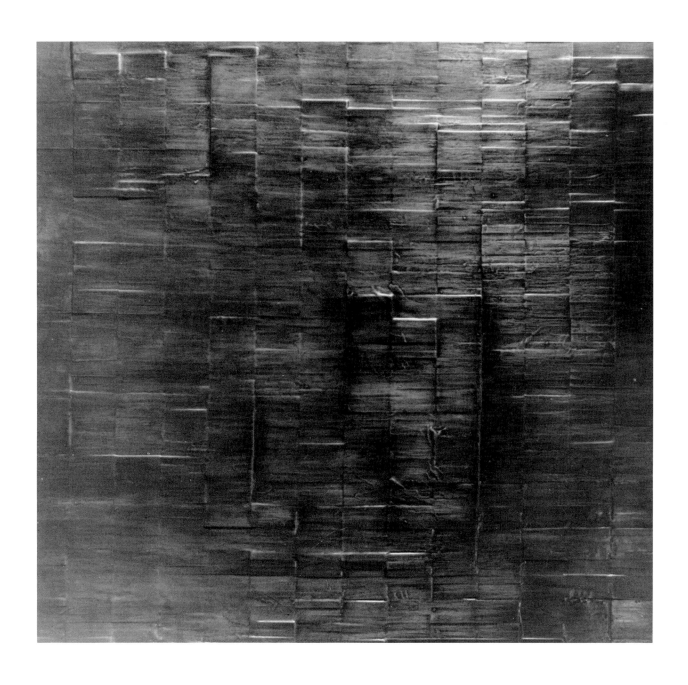

41. *Tablet 151*, 1966–67
 Black epoxy on wood
 71 1/2 × 77 1/2 inches
 Private collection

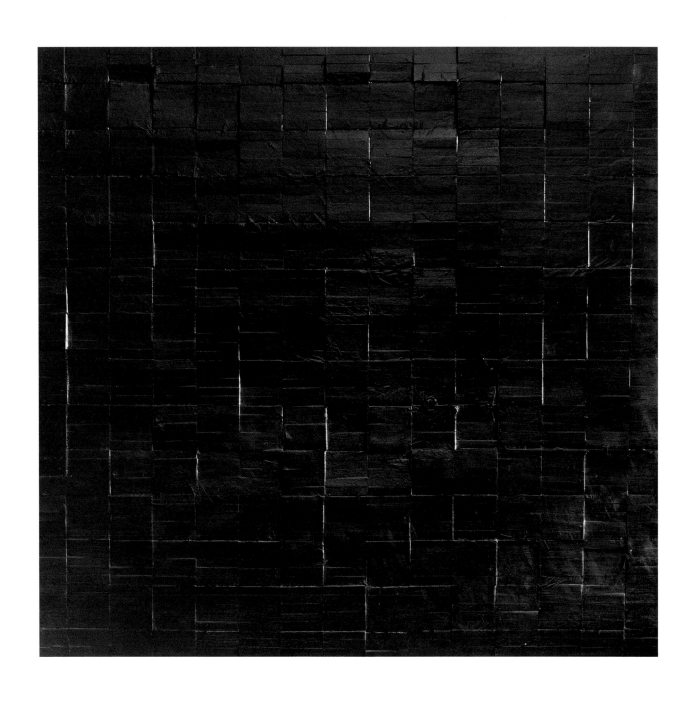

42. *Tablet 152*, 1966
 Black epoxy on wood
 66 × 72 inches

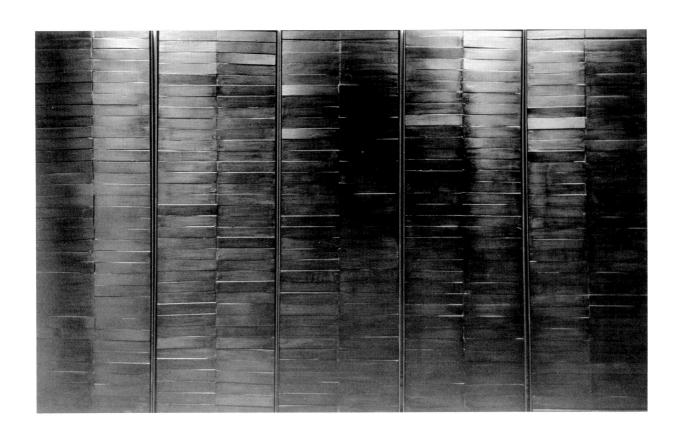

43. *Tablet 154, 155, 156, 157, 158,*
 1966–67 (see p. 30)
 Black epoxy on wood
 88 × 144 inches

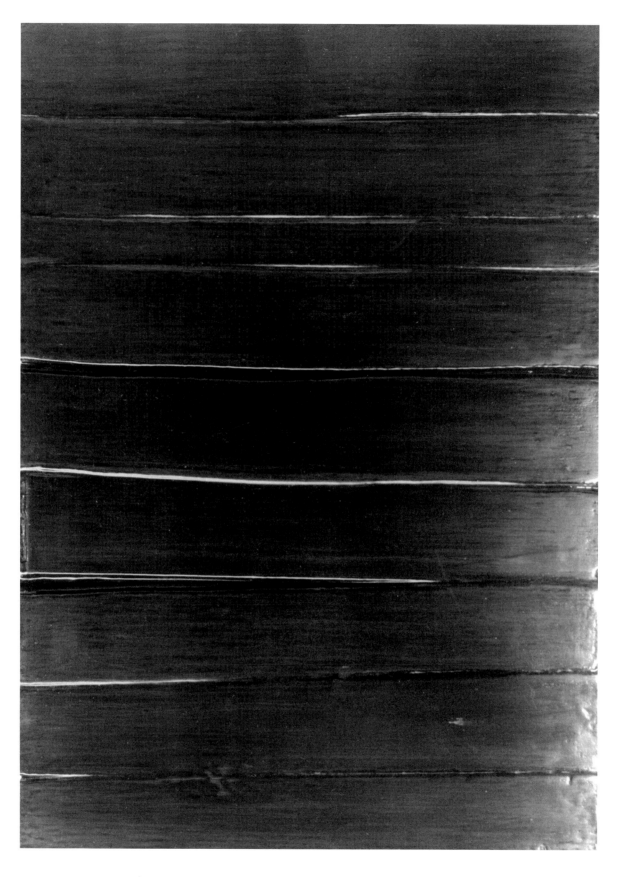

44. *Tablet 159*, 1966–67
 Black epoxy on wood
 18 1/2 × 13 3/4 inches
 Private collection

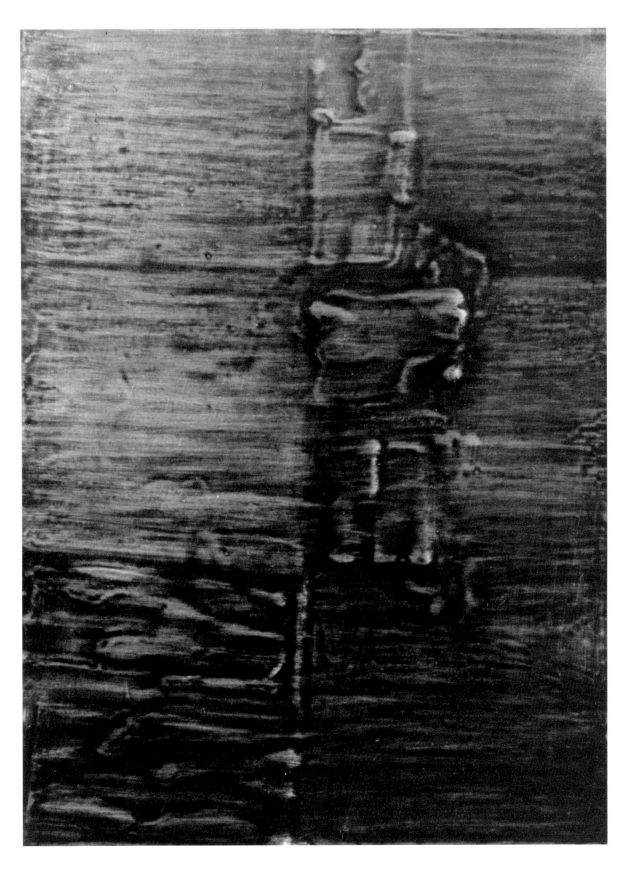

45. *Tablet 160*, 1966
 Black epoxy on wood
 17 × 13 inches
 Collection of Doug Young, Honolulu

46. *Tablet 161*, 1967
 White enamel on wood
 48 1/4 × 36 inches
 Collection of the Grey Art Gallery and
 Study Center, New York University,
 New York City; gift of Richard,
 Gabrielle, and Hillary Burns

84

47. *Tablet 162*, 1967
White epoxy on wood
47 × 38 7/8 inches
Collection of the Newark Museum,
Newark; anonymous gift

48. *Tablet 170*, 1967–68
 White enamel on aluminum
 23 1/2 × 24 inches
 Estate of John Gordon, Palm Beach, Florida

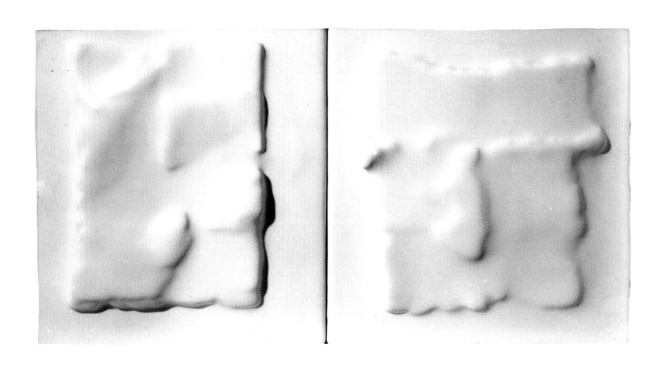

49. *Tablet 171,* 1967
 White epoxy on foam on wood
 6 × 11 inches
 Collection of Gabrielle Burns,
 Arlington, Texas

50. *Tablet 173*, 1967
 Black enamel on wood
 72 × 48 inches

88

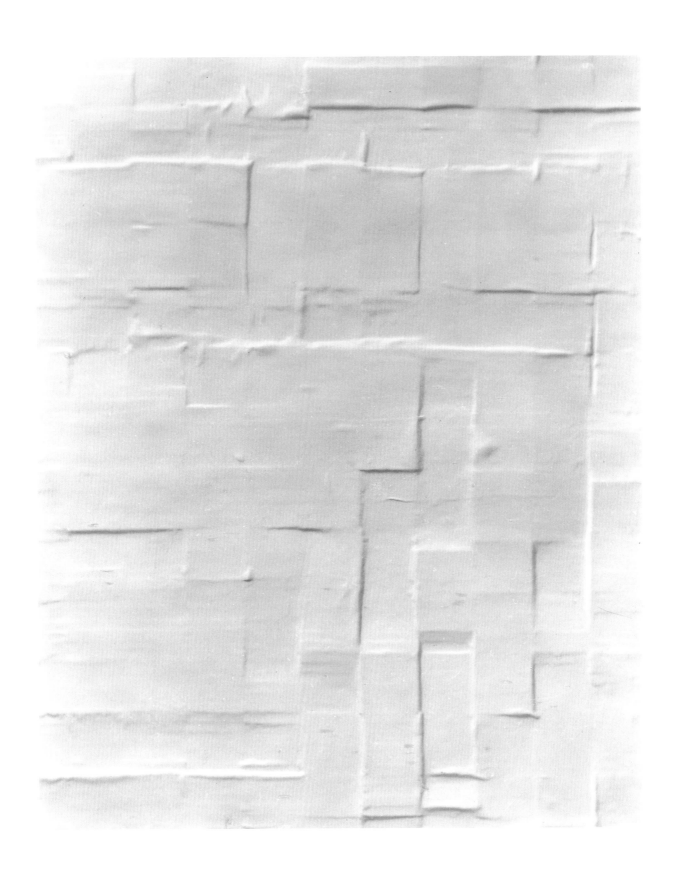

51. *Tablet 175*, 1967–68
 White enamel on fiberglass on wood
 72 1/2 × 60 1/4 inches

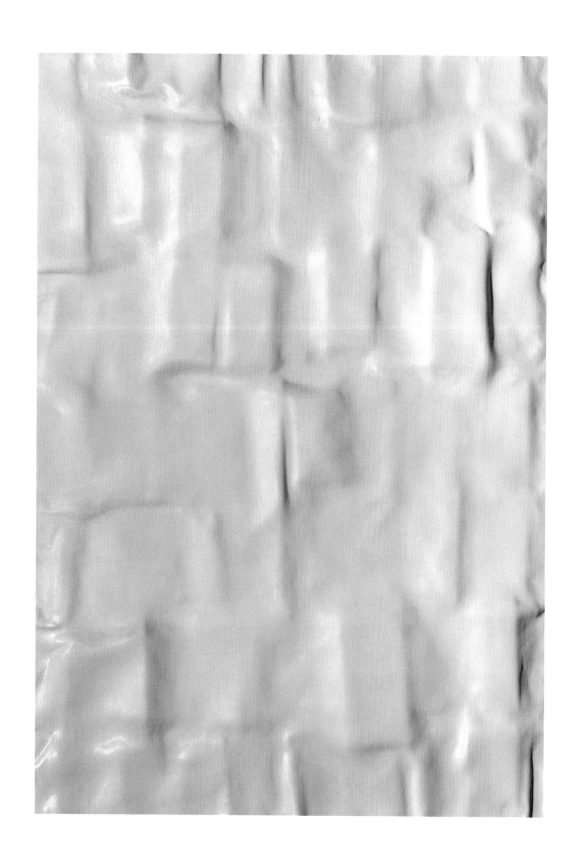

52. *Tablet 176*, 1968
 White epoxy on fiberglass
 42 1/2 × 29 1/4 inches
 Collection of the Herbert F. Johnson
 Museum of Art, Cornell University,
 Ithaca, New York; anonymous gift

53. *Tablet 183*, 1968
 White enamel on fiberglass
 60 1/4 × 60 inches
 Private collection

54. *Tablet 185*, 1968
 Black enamel on fiberglass
 60 × 37 1/4 inches

NEO-EXPRESSIONIST PAINTINGS

and

THE RETURN TO MINIMALISM

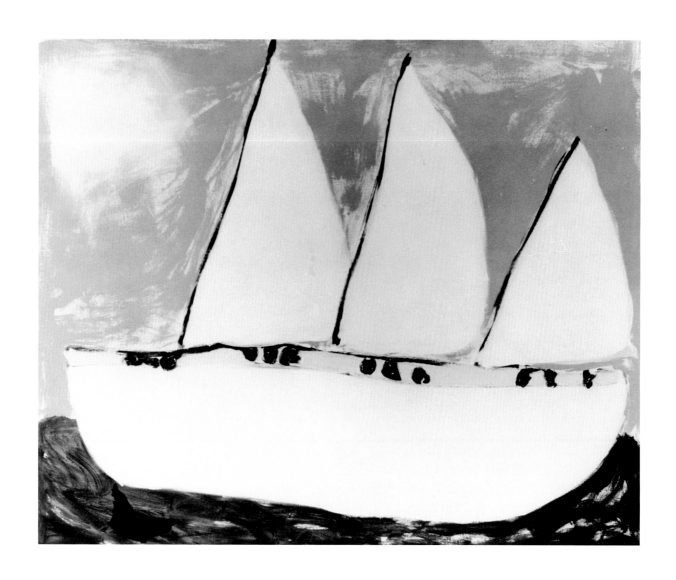

55. *The Big White Ship,* 1969
 Acrylic on canvas
 50 1/2 × 60 inches
 Westinghouse Art
 Collection, Pittsburgh

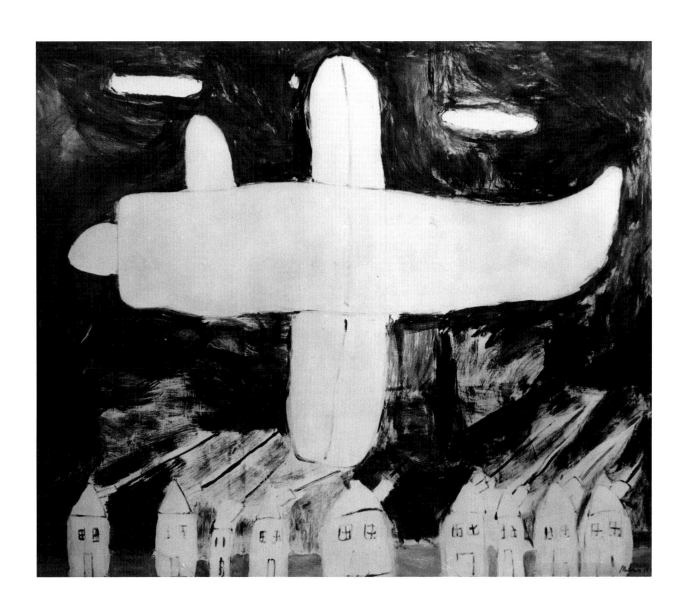

56. *Blue Sky with Two White Clouds,* 1970
 Acrylic on canvas
 90 × 108 inches
 Collection of Dr. Sabra W. Calland,
 courtesy of the Indianapolis Museum
 of Art, Indianapolis

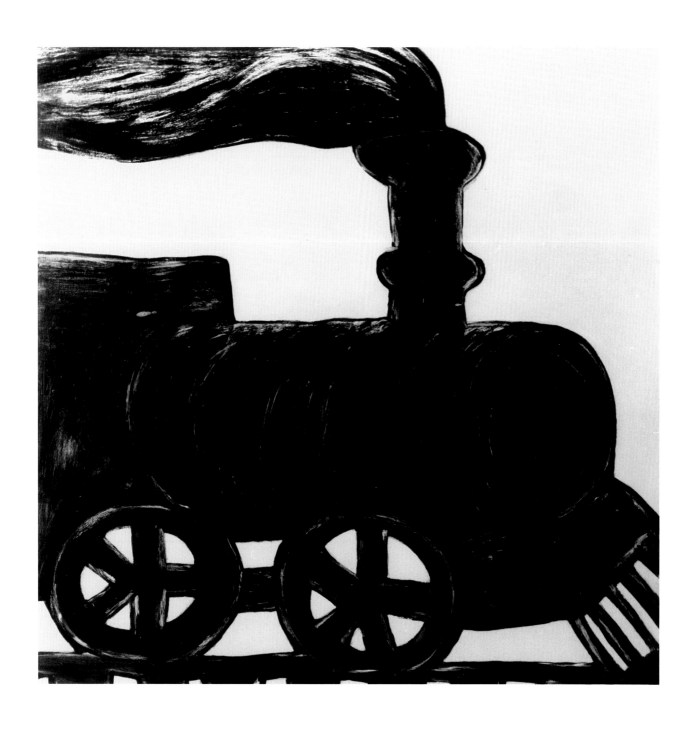

57. *The Red Barn Train*, 1972–73
 Acrylic on canvas
 72 × 72 inches
 Collection of the Indianapolis Museum
 of Art, Indianapolis; gift of the artist

96

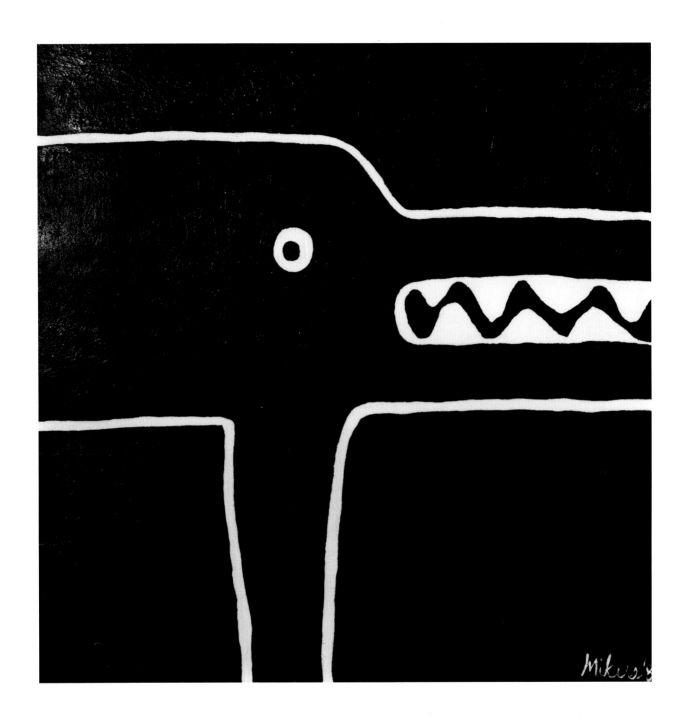

58. *Black Dragon*, 1981
 Acrylic on canvas
 48 × 48 inches
 Private collection

59. *Tablet 6 (Series II)*, 1986–87
Oil on canvas
72 × 48 inches

60. *Tablet 3 (Series II)*, 1987
 Oil on canvas
 66 × 66 inches

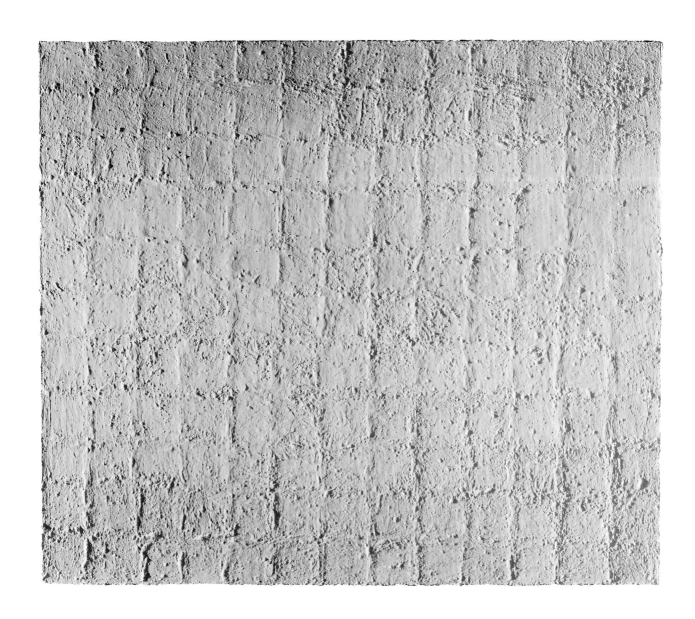

61. *The Green One*, 1988
 Oil on canvas
 66 1/4 × 78 5/8 inches

100

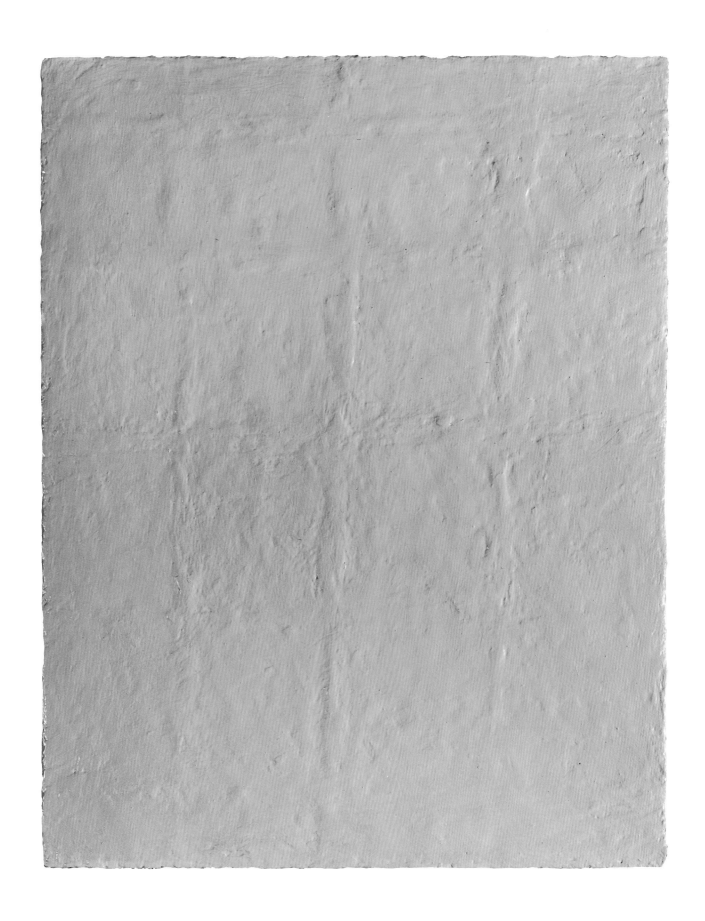

62. *The Grey One*, 1988
Oil on canvas
30 1/4 × 24 1/2 inches

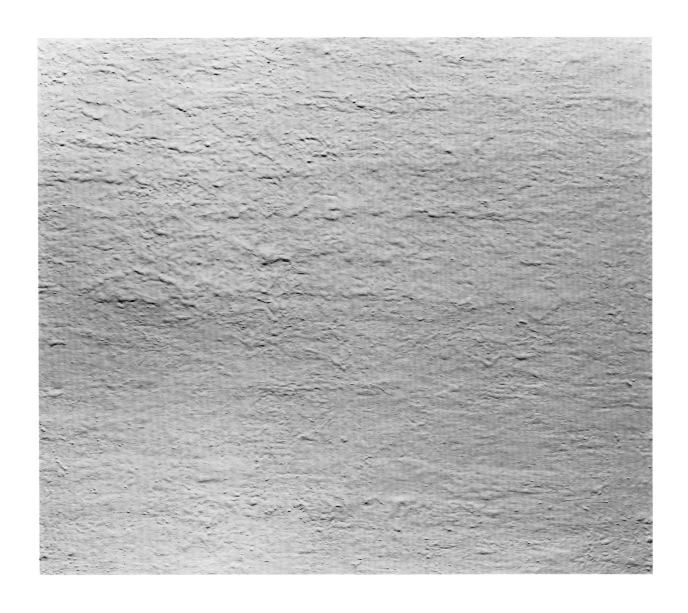

63. *The Green One II*, 1989–90
 Oil on canvas
 66 1/4 × 78 1/4 inches

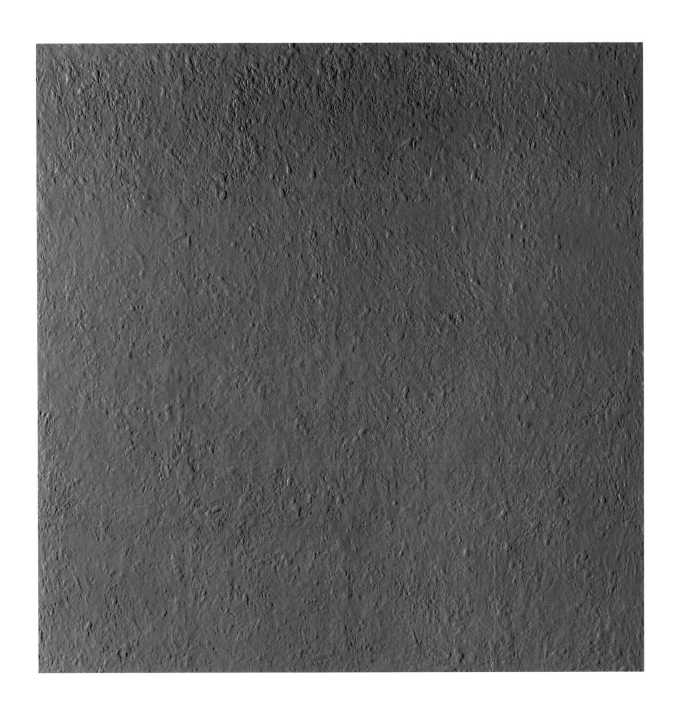

64. *The Blue One*, 1990
 Oil on canvas
 66 1/4 × 66 1/4 inches

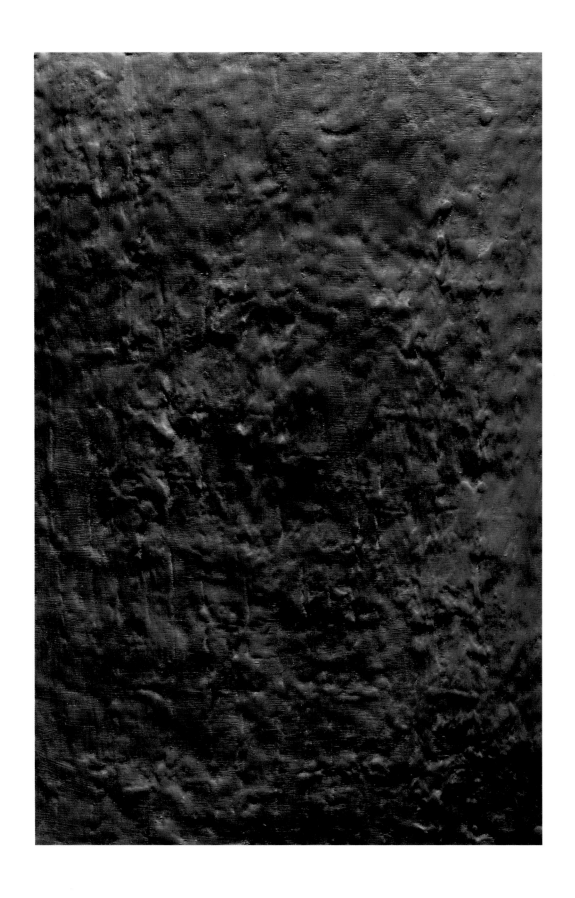

65. *The Dark Grey One*, 1990
 Oil on canvas
 30 1/4 × 20 1/4 inches

104

66. *Tablet Litho 28,* Tamarind 2380, 1968
Lithograph (aluminum) on German etching paper
35 × 24 1/2 inches (sheet)
Printer: Serge Lozingat
Collection of the Norton Simon Museum,
Pasadena, California

PART II

COLLAGES, RELIEFS, AND PAPERFOLDS

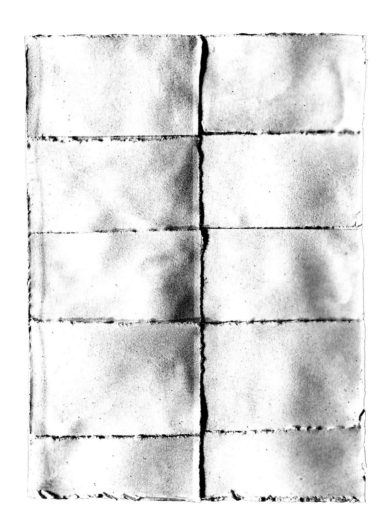

67. *Collage Fold #4*, 1962
 Rag paper on board
 5 × 4 1/4 inches
 Private collection

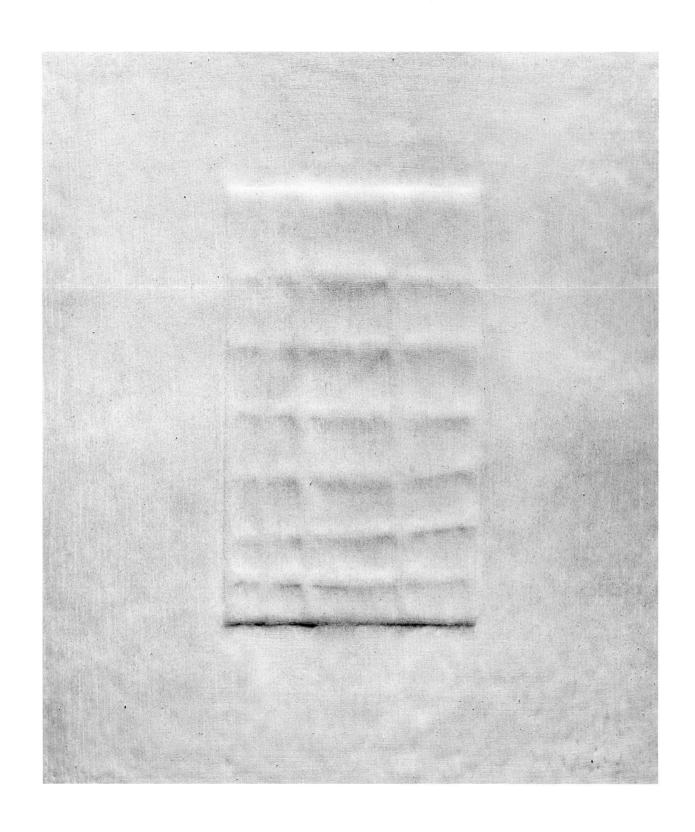

68. *Relief 16,* 1963
 Flat enamel on index card on board
 9 × 8 inches
 Estate of Bertha Mikus

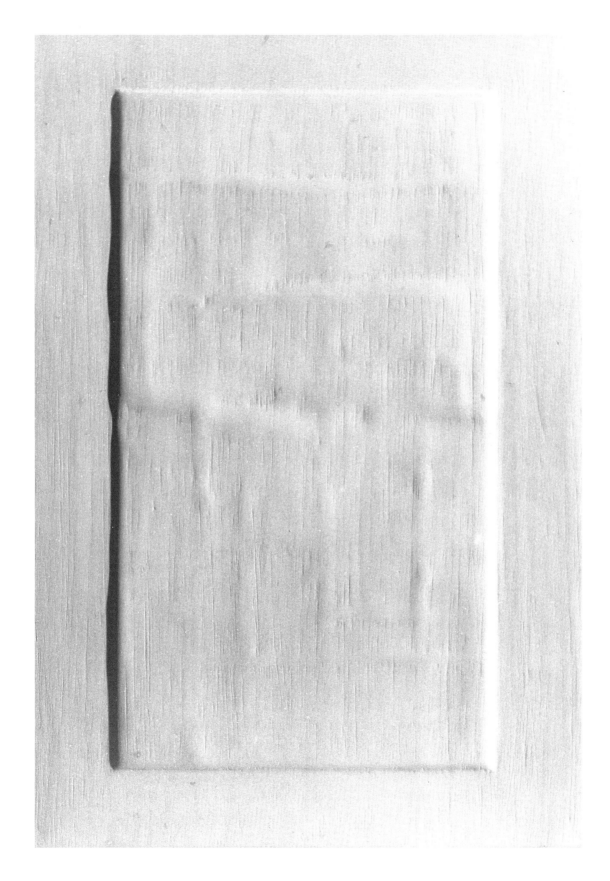

69. *Relief 19,* 1964
 Flat enamel on board
 19 × 13 1/2 inches
 Private collection

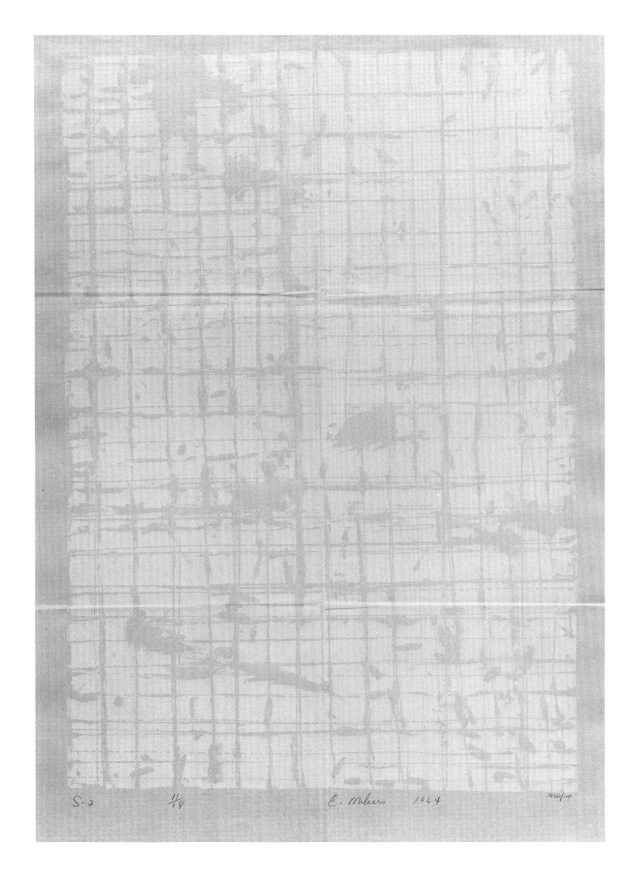

70. *White Serigraph Paperfold #2*, 11/18, 1964
 Ink on Fabriano paper
 29 × 19 inches
 Printer: Steve Poleskie

112

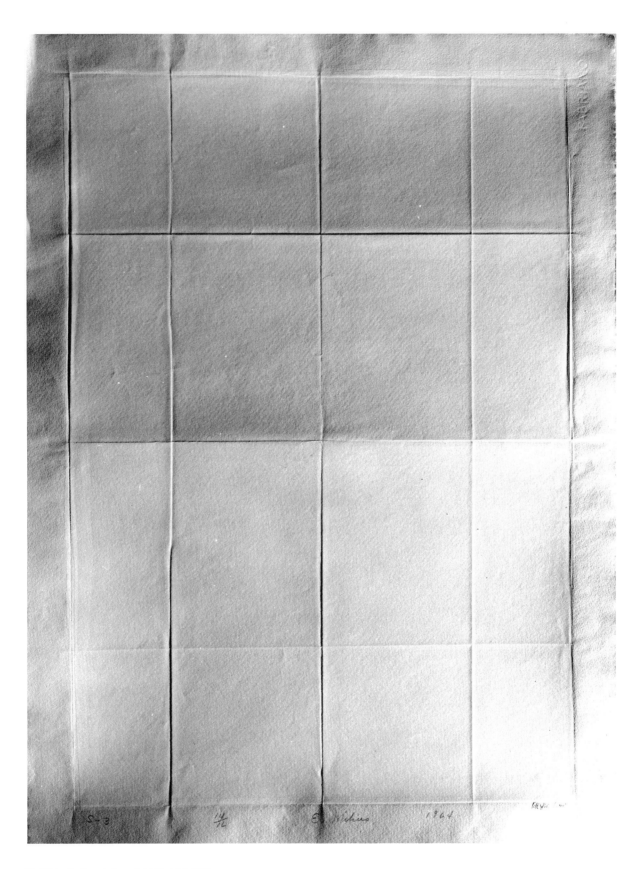

71. *White Serigraph Paperfold #3*, 4/16, 1964
Ink on Fabriano paper
26 × 19 inches
Printer: Steve Poleskie

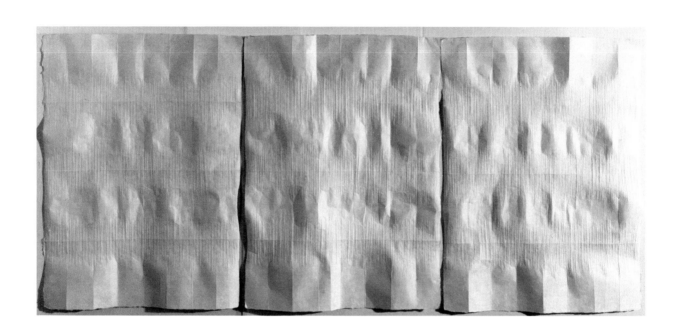

72. *Hand Folded Fold Triptych*, 1979
 White Inomachi vellum
 22 × 52 1/2 inches

114

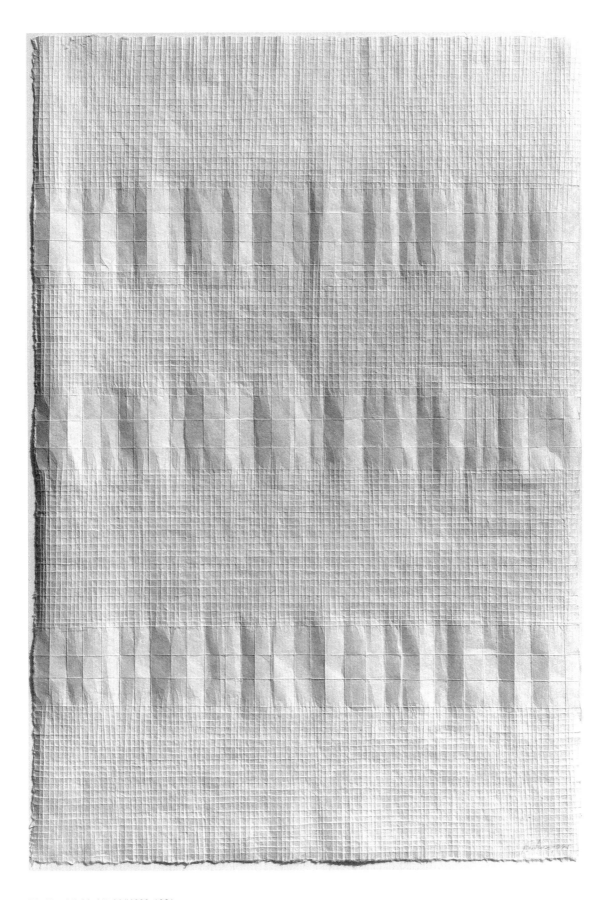

73. *Hand Folded Fold #1000*, 1981
 White Inomachi vellum
 34 × 30 inches

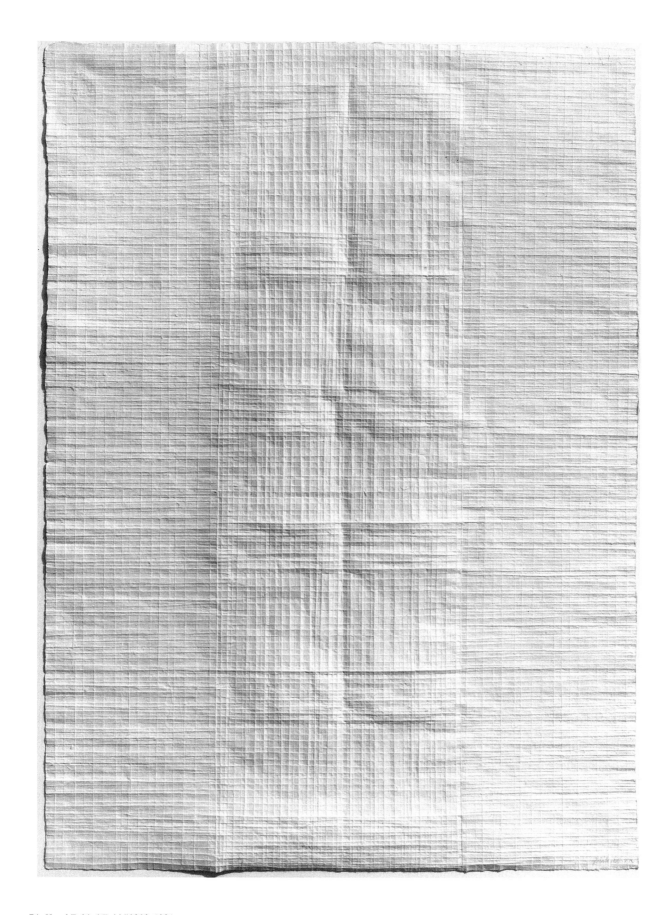

74. *Hand Folded Fold #1010*, 1981
 White Inomachi vellum
 40 × 28 1/2 inches

116

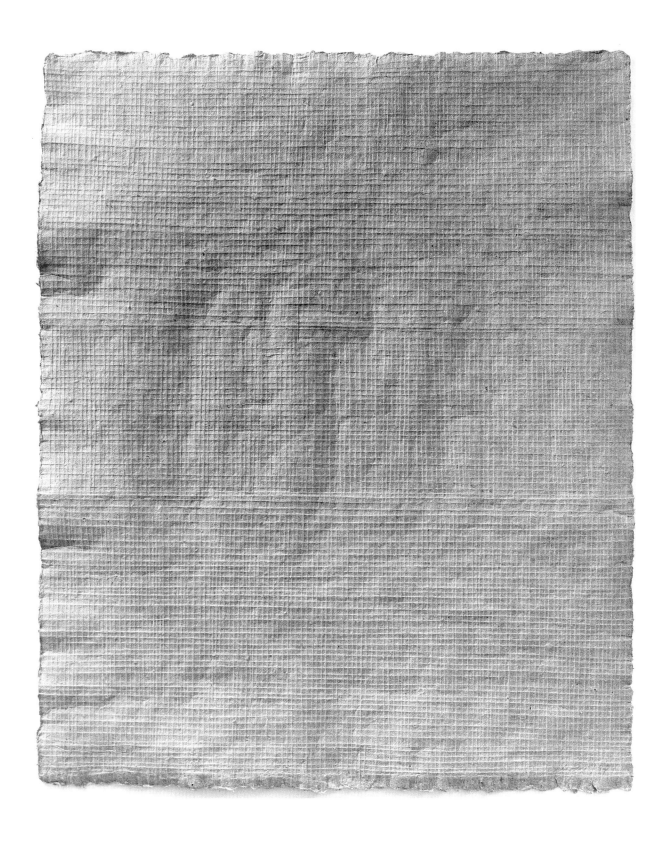

75. *Hand Folded Fold #1014*, 1981
 Gray Zarr paper
 28 3/4 × 23 1/2 inches

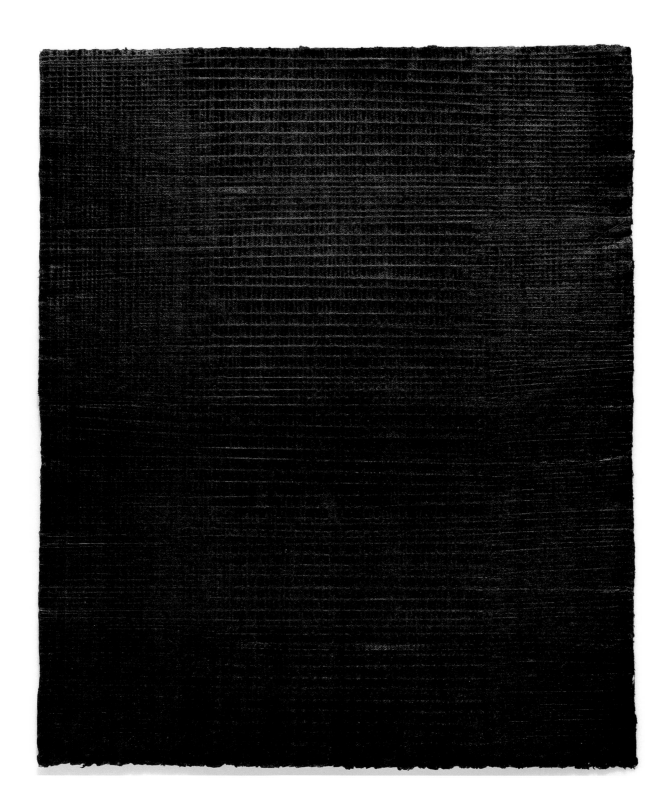

76. *Hand Folded Fold #1038*, 1981
 Black ink on Zarr paper
 28 1/2 × 24 1/4 inches

77. *Hand Folded Fold #1016,* 1982
 White Inomachi vellum
 32 × 23 inches
 Collection of Judith Bernstock, Ithaca, New York

78. *Hand Folded Fold #1020*, 1982
 White Inomachi vellum
 40 × 28 1/4 inches

79. *Hand Folded Fold #1021*, 1982
 Black ink on Inomachi vellum
 31 1/2 × 23 inches
 Private collection

80. *Hand Folded Fold #1025,* 1982–83
 White Inomachi vellum
 39 1/2 × 28 3/4 inches
 Collection of Anna Geske, Ithaca, New York

81. *Hand Folded Fold #1027*, 1983
 White Inomachi vellum
 34 × 23 inches

82. *Hand Folded Fold #1028,* 1983
 White Inomachi vellum
 40 × 30 inches
 Collection of Hillary Burns, Grand Haven, Michigan;
 formerly collection of Bertha Mikus

124

83. *Hand Folded Fold #1045*, 1985
 White Inomachi vellum
 26 1/4 × 19 1/2 inches

84. *Hand Folded Double Fold #1061*, 1988
White Inomachi vellum
33 × 23 1/4 inches

126

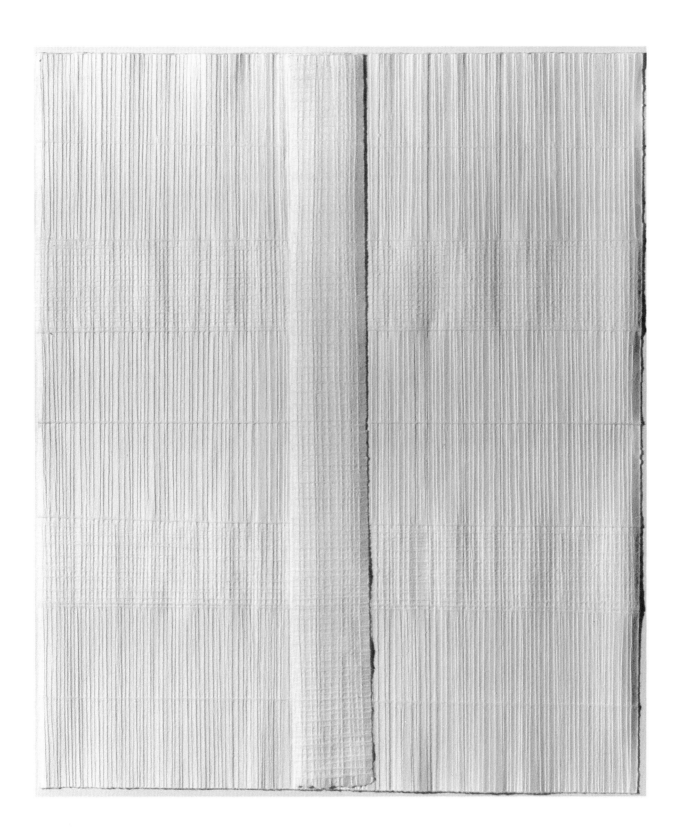

85. *Hand Folded Double Fold #1070*, 1990
 White copperplate
 18 3/4 × 16 inches

PART III
PRINTS

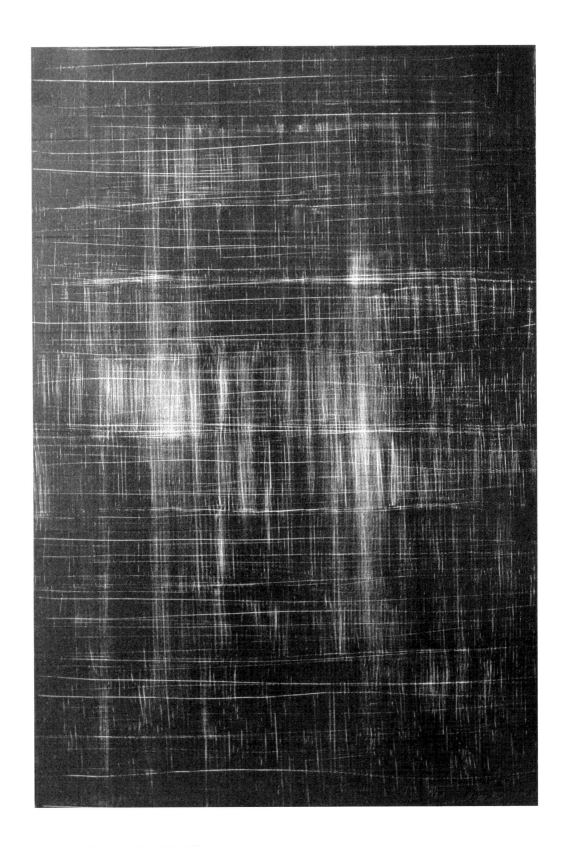

86. *Tablet Litho 3,* Tamarind 2353, 1968
Lithograph (stone) on German etching paper
20 1/4 × 14 (sheet)
Printer: Serge Lozingat
Collection of the National Gallery of Art,
Washington, D.C.; gift of Dorothy J. and
Benjamin B. Smith

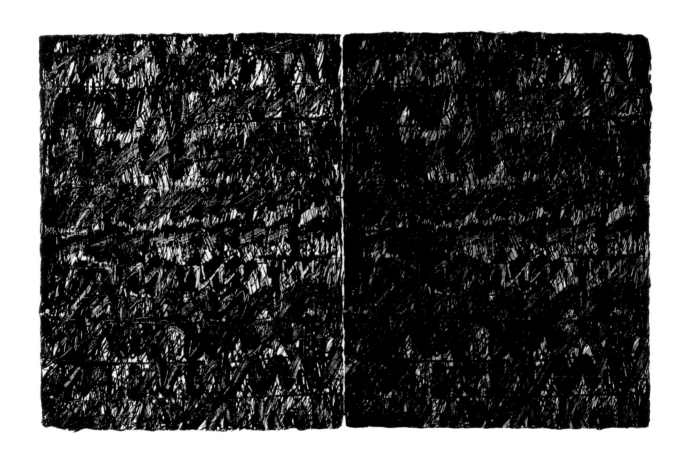

87. *Tablet Litho 13,* Tamarind 2355, 1968
 Lithograph (stone) on Inomachi nacre paper
 23 × 36 inches (two hinged sheets)
 Printer: Frank Akers
 Collection of the Amon Carter Museum of
 Western Art, Fort Worth

132

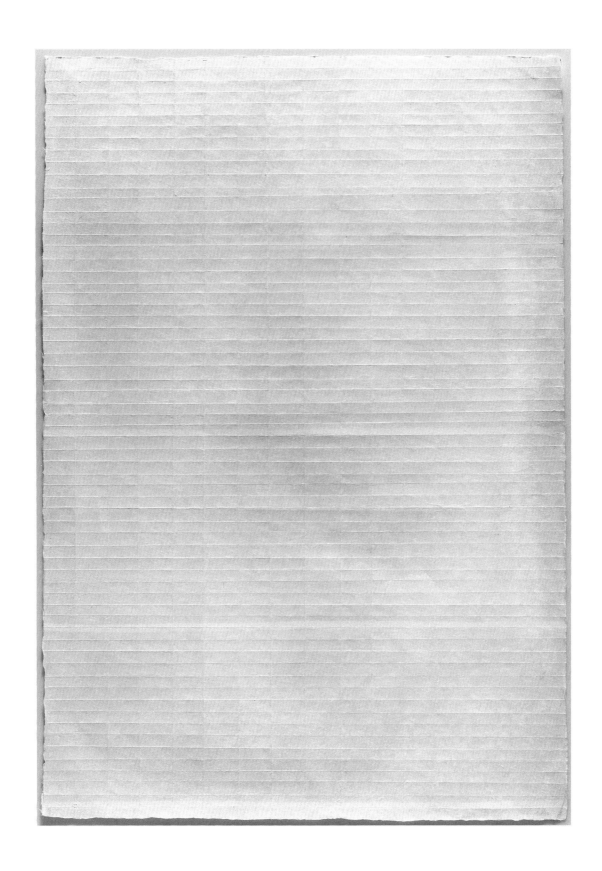

88. *Tablet Litho 18,* Tamarind 2368, 1968
 Lithograph (stone) on Inomachi nacre paper
 41 1/2 × 29 1/8 inches (sheet)
 Printer: Robert Rogers
 Collection of the Los Angeles County
 Museum of Art, Los Angeles

89. *Tablet Litho 26,* Tamarind 2379 and 2379A, 1968
 Lithograph (stone) on Inomachi nacre paper
 83 × 29 1/2 inches (two hinged sheets)
 Printer: Robert Rogers
 Collection of the Cincinnati Museum of Art, Cincinnati;
 gift of Murray Kagel

90. *Tablet Litho 2,* Tamarind 2350, state II, 1968
 Lithograph (stone) on Rives BFK paper
 36 × 24 inches (sheet)
 Printer: Jean Milant
 Collection of the Whitney Museum of American Art,
 New York City

PUBLIC COLLECTIONS

PAINTINGS

Aldrich Museum of Contemporary Art, Ridgefield, Connecticut; museum purchase: *Tablet 49**

Birmingham Museum of Art, Birmingham, Alabama; gift of Silvia Pizitz: *Tablet 20**

Brooklyn Museum, Brooklyn, New York; anonymous gift: *Tablet 62** and *Tablet 82**

Grey Art Gallery and Study Center, New York University, New York City; gift of Richard, Gabrielle, and Hillary Burns: *Tablet 161**

Housatonic Museum of Art, Housatonic Community College, Bridgeport, Connecticut (not included in this book)†

Indianapolis Museum of Art, Indianapolis; gift of the artist: *The Red Barn Train;*† on loan from Dr. Sabra W. Calland: *Blue Sky with Two White Clouds*†

Herbert F. Johnson Museum of Art, Cornell University, Ithaca, New York; anonymous gift: *Tablet 176**

Lewis and Clark College, Portland, Oregon (not included in this book)†

Museum of Arts and Sciences, Staten Island, New York; gift of the Pace Gallery: *Tablet 106** joined to *Tablet 85** (not included in this book)

Museum of Fine Arts, Springfield, Massachusetts; gift of the Pace Gallery: *Tablet 109**

Museum of Modern Art, New York City; gift of Louise Nevelson: *Tablet 84**

Newark Museum, Newark; anonymous gift: *Tablet 162**

Pace Gallery, New York City: *Tablet 120**

Palm Springs Desert Museum, Palm Springs, California; gift of Dorothy J. and Benjamin B. Smith: *Tablet 111**

Edwin A. Ulrich Museum of Art, Wichita State University, Wichita, Kansas (not included in this book)†

University of Denver School of Art, Denver; gift of the artist: *Abstract Cantata*‡ and *Tablet 43** (not included in this book)

Weatherspoon Art Gallery, University of North Carolina, Greensboro (not included in this book)†

Westinghouse Art Collection, Pittsburgh; museum purchase: *The Big White Ship*†

Whitney Museum of American Art, New York City; gift of Fred Mueller: *Tablet 58**

FOLDS

Cincinnati Museum of Art, Cincinnati; gift of the artist: *White Paperfold Flyer**

Coco Gallery, Kyoto, Japan; gift of Mary Baskett Gallery, Cincinnati: hand-folded paperfold* (untitled)

The Gallery, Kyoto, Japan; gift of Mary Baskett Gallery, Cincinnati: hand-folded paperfold* (untitled)

Newark Public Library, Newark; partial gift of the artist and partial museum purchase: folded paper print* (untitled)

PRINTS

Birmingham Museum of Art, Birmingham, Alabama; gift of the artist: lithograph* (untitled)

Newark Public Library, Newark; partial gift of the artist and partial museum purchase: *White Serigraph Paperfold #3,** two lithographs† (untitled), and serigraph† (untitled)

*Minimalist work.
†Neo-expressionist work.
‡Early work.

TAMARIND LITHOGRAPHS

*Tablet Litho 1,** 1968 (June 3–6). Tamarind 2350 and 2350A. Lithograph (stone) in light yellow on two hinged sheets, 72 × 24 inches (total sheet). Edition: 20 on Rives BFK, plus 9 on Magnani Italia. Printer: Jean Milant at Tamarind Lithography Workshop, Los Angeles.
- Amon Carter Museum of Western Art, Fort Worth; museum purchase; 209.68 and 210.68
- Los Angeles County Museum of Art, Los Angeles; museum purchase with county funds; 68.4.164 and 68.4.165
- Museum of Modern Art, New York City; gift of Kleiner, Bell and Company; 1117.68.a-b
- National Gallery of Art, Washington, D.C.; gift of Dorothy J. and Benjamin B. Smith; 1984.34.297.a
- Newark Public Library, Newark; partial gift of the artist and partial museum purchase; M636.1.62
- Norton Simon Museum, Pasadena, California; museum purchase; 71.7.48 and 71.7.49

*Tablet Litho 2,** 1968 (June 3–7). Tamarind 2350, state II. Lithograph (stone) in light yellow and black, 36 × 24 inches (sheet). Edition: 10, plus 9 on Rives BFK. Printer: Jean Milant at Tamarind Lithography Workshop, Los Angeles.
- Amon Carter Museum of Western Art, Fort Worth; museum purchase; 211.68
- Los Angeles County Museum of Art, Los Angeles; museum purchase with county funds; 68.4.166
- Museum of Modern Art, New York City; gift of Kleiner, Bell and Company; 467.71
- National Gallery of Art, Washington, D.C.; gift of Dorothy J. and Benjamin B. Smith; 1984.34.298
- Newark Public Library, Newark; partial gift of the artist and partial museum purchase; M636.2.62
- Norton Simon Museum, Pasadena, California; museum purchase; 69.92.439
- Victoria and Albert Museum, London; museum purchase
- Whitney Museum of American Art, New York City; museum purchase; 72.142

*Tablet Litho 3,** 1968 (June 11–13). Tamarind 2353. Lithograph (stone) in black, 20 1/4 × 14 inches. Edition: 10 on J. Green paper, plus 9 on German etching paper. Printer: Serge Lozingot at Tamarind Lithography Workshop, Los Angeles.
- Amon Carter Museum of Western Art, Fort Worth; museum purchase; 214.68

- Cincinnati Museum of Art, Cincinnati; gift of Murray Kagel; 1970.732
- Los Angeles County Museum of Art, Los Angeles; museum purchase with county funds; 68.4.169
- Museum of Modern Art, New York City; gift of Kleiner, Bell and Company; 1120.68
- National Gallery of Art, Washington, D.C.; gift of Dorothy J. and Benjamin B. Smith; 1984.34.301
- New York Public Library, New York City; anonymous gift
- Newark Public Library, Newark; partial gift of the artist and partial museum purchase; M636.6.61
- Norton Simon Museum, Pasadena, California; museum purchase; 69.92.441

*Tablet Litho 4,** 1968 (June 4–14). Tamarind 2351. Lithograph (stone) in beige and white, 28 × 18 inches (sheet). Edition: 20 on German etching paper, plus 9 on copperplate deluxe. Printer: Frank Akers at Tamarind Lithography Workshop, Los Angeles.
- Amon Carter Museum of Western Art, Fort Worth; museum purchase; 212.68
- Los Angeles County Museum of Art, Los Angeles; museum purchase with county funds; 68.4.167
- Museum of Modern Art, New York City; gift of Kleiner, Bell and Company; 1118.68
- National Gallery of Art, Washington, D.C.; gift of Dorothy J. and Benjamin B. Smith; 1984.34.299
- Newark Public Library, Newark; partial gift of the artist and partial museum purchase; M636.4.62
- Norton Simon Museum, Pasadena, California; museum purchase; 69.92.440

*Tablet Litho 5,** 1968 (June 7–19). Tamarind 2352. Lithograph (stone) in black, 30 × 21 3/4 inches (sheet). Edition: 20 on copperplate deluxe paper, plus 9 on German etching paper. Printer: Ed Hughes, Tamarind Lithography Workshop, Los Angeles.
- Amon Carter Museum of Western Art, Fort Worth; museum purchase; 213.68
- Los Angeles County Museum of Art, Los Angeles; museum purchase with county funds; 68.4.168
- Museum of Modern Art, New York City; gift of Kleiner, Bell and Company; 1119.68
- National Gallery of Art, Washington, D.C.; gift of Dorothy J. and Benjamin B. Smith; 1984.34.300
- Newark Public Library, Newark;

partial gift of the artist and partial museum purchase; M636.5.61
- Norton Simon Museum, Pasadena, California; museum purchase; 71.7.50

*Tablet Litho 6,** 1968 (June 19–25). Tamarind 2365. Lithograph (stone) in blue, 20 1/4 × 14 inches (sheet). Edition: 20 on copperplate deluxe paper, plus 9 on German etching paper. Printer: Serge Lozingot at Tamarind Lithography Workshop, Los Angeles.
- Amon Carter Museum of Western Art, Fort Worth; museum purchase; 220.68
- Los Angeles County Museum of Art, Los Angeles; museum purchase with county funds; 68.4.175
- Museum of Modern Art, New York City; gift of Kleiner, Bell and Company; 1126.68
- Newark Public Library, Newark; partial gift of the artist and partial museum purchase; M636.12.62
- National Gallery of Art, Washington, D.C.; gift of Dorothy J. and Benjamin B. Smith; 1984.34.309
- Norton Simon Museum, Pasadena, California; museum purchase; 69.92.444

*Tablet Litho 7,** 1968 (June 12–27). Tamarind 2354, state II. Lithograph (aluminum) in yellow-gray, 34 × 24 inches (sheet). Edition: 10, plus 9 on white Inomachi nacre paper. Printer: Robert Rogers at Tamarind Lithography Workshop, Los Angeles.
- Amon Carter Museum of Western Art, Fort Worth; museum purchase; 215.68
- Los Angeles County Museum of Art, Los Angeles; museum purchase with county funds; 68.4.170
- Museum of Modern Art, New York City; gift of Kleiner, Bell and Company; 1121.68
- National Gallery of Art, Washington, D.C.; gift of Dorothy J. and Benjamin B. Smith; 1984.34.303
- Norton Simon Museum, Pasadena, California; museum purchase; 71.7.51

*Tablet 8,** 1968 (June 12–28). Tamarind 2354, state III. Lithograph (aluminum) in black and blue-black, 34 × 24 inches (sheet). Edition: 10, plus 9 on white Inomachi nacre paper. Printer: Robert Rogers at Tamarind Lithography Workshop, Los Angeles.
- Amon Carter Museum of Western Art, Fort Worth; museum purchase; 216.68
- Birmingham Museum of Art, Birmingham, Alabama; gift of the artist. 86.43

- Los Angeles County Museum of Art, Los Angeles; museum purchase with county funds; 68.4.171
- Museum of Modern Art, New York City; gift of Kleiner, Bell and Company; 1122.68
- National Gallery of Art, Washington, D.C.; gift of Dorothy J. and Benjamin B. Smith; 1984.34.304
- Newark Public Library, Newark; partial gift of the artist and partial museum purchase; M636.7.62
- Norton Simon Museum, Pasadena, California; museum purchase; 71.7.52

*Tablet Litho 9,** 1968 (June 20–28). Tamarind 2357, state II. Lithograph (stone) in black, 32 × 23 inches (sheet). Edition: 10 on German etching paper, plus 9 on copperplate deluxe. Printer: Serge Lozingot at Tamarind Lithography Workshop, Los Angeles.
- Amon Carter Museum of Western Art, Fort Worth; museum purchase; 219.68
- Cincinnati Museum of Art, Cincinnati; gift of Murray Kagel; 1970.733
- Los Angeles County Museum of Art, Los Angeles; museum purchase with county funds; 68.4.174
- Museum of Modern Art, New York City; gift of Kleiner, Bell and Company; 1125.68
- National Gallery of Art, Washington, D.C.; gift of Dorothy J. and Benjamin B. Smith; 1984.34.308
- Newark Public Library, Newark; partial gift of the artist and partial museum purchase; M636.11.61
- Norton Simon Museum, Pasadena, California; museum purchase; 69.92.443

*Tablet Litho 10,** 1968 (June 21–28). Tamarind 2356. Lithograph (aluminum) in blue-black, 32 1/2 × 23 inches (sheet). Edition: 20, plus 9 on natural Inomachi nacre paper. Printer: Jean Milant at Tamarind Lithography Workshop, Los Angeles.
- Amon Carter Museum of Western Art, Fort Worth; museum purchase; 217.68
- Los Angeles County Museum of Art, Los Angeles; museum purchase with county funds; 68.4.172
- Museum of Modern Art, New York City; gift of Kleiner, Bell and Company; 1123.68
- National Gallery of Art, Washington, D.C.; gift of Dorothy J. and Benjamin B. Smith; 1984.34.306
- Newark Public Library, Newark;

partial gift of the artist and partial museum purchase; M636.9.62
- Norton Simon Museum, Pasadena, California; museum purchase; 71.7.53

*Tablet Litho 11,** 1968 (June 20–July 1). Tamarind 2357. Lithograph (stone) in black, 32 × 23 inches (sheet). Edition: 20 on German etching paper, plus 9 on copperplate deluxe. Printer: Serge Lozingot at Tamarind Lithography Workshop, Los Angeles.
- Amon Carter Museum of Western Art, Fort Worth; museum purchase; 218.68
- Los Angeles County Museum of Art, Los Angeles; museum purchase with county funds; 68.4.173
- Museum of Modern Art, New York City; gift of Kleiner, Bell and Company; 1124.68
- National Gallery of Art, Washington, D.C.; gift of Dorothy J. and Benjamin B. Smith; 1984.34.307
- Newark Public Library, Newark; partial gift of the artist and partial museum purchase; M636.10.61
- Norton Simon Museum, Pasadena, California; museum purchase; 69.92.442

*Tablet Litho 12,** 1968 (June 28–July 1). Tamarind 2366. Lithograph (onyx) in gray, 26 1/2 × 19 inches (sheet). Edition: 20 on German etching paper, plus 9 on copperplate deluxe. Printer: David Folkman at Tamarind Lithography Workshop, Los Angeles.
- Amon Carter Museum of Western Art, Fort Worth; museum purchase; 315.68
- Los Angeles County Museum of Art, Los Angeles; museum purchase with county funds; 70.81.63
- Museum of Modern Art, New York City; gift of Kleiner, Bell and Company; 531.69
- National Gallery of Art, Washington, D.C.; gift of Dorothy J. and Benjamin B. Smith; 1984.34.310
- Newark Public Library, Newark; partial gift of the artist and partial museum purchase; M636.13.61
- Norton Simon Museum, Pasadena, California; museum purchase; 69.92.491

*Tablet Litho 13** (left sheet), 1968 (June 14–July 1). Tamarind 2355 and 2355A. Lithograph (stone) in black on two hinged sheets, 23 × 36 inches (total sheet). Edition: 20, plus 9 on white Inomachi nacre paper. Printer: Frank Akers at Tamarind Lithography Workshop, Los Angeles.
- Amon Carter Museum of Western Art, Fort Worth; museum purchase; 313.68 and 314.68

- Los Angeles County Museum of Art, Los Angeles; museum purchase with county funds; M.70.81.61 and M.70.81.62
- Museum of Modern Art, New York City; gift of Kleiner, Bell and Company; 529.69.a-b
- National Gallery of Art, Washington, D.C.; gift of Dorothy J. and Benjamin B. Smith; 1984.34.305.a
- Newark Public Library, Newark; partial gift of the artist and partial museum purchase; M636.8.62
- Norton Simon Museum, Pasadena, California; museum purchase; 69.92.489 and 69.92.490

*Tablet Litho 14,** 1968 (June 12–July 1). Tamarind 2354. Lithograph (aluminum) in white and gray, 34 × 23 inches (sheet). Edition: 20, plus 9 on white Inomachi nacre paper. Printer: Robert Rogers at Tamarind Lithography Workshop. Los Angeles.
- Amon Carter Museum of Western Art, Fort Worth; museum purchase; 312.68
- Los Angeles County Museum of Art, Los Angeles; museum purchase with county funds; M.70.81.60
- Museum of Modern Art, New York City; gift of Kleiner, Bell and Company; 528.69
- National Gallery of Art, Washington, D.C.; gift of Dorothy J. and Benjamin B. Smith; 1984.34.302
- Newark Public Library, Newark; partial gift of the artist and partial museum purchase; M636.3.62 (two copies)
- Norton Simon Museum, Pasadena, California; museum purchase; 69.92.488

*Tablet Litho 15,** 1968 (June 28–July 3). Tamarind 2369. Lithograph (aluminum) in black, 32 × 23 inches (sheet). Edition: 20 on Magnani Italia, plus 9 on copperplate deluxe. Printer: Theo Wujcik at Tamarind Lithography Workshop, Los Angeles.
- Amon Carter Museum of Western Art, Fort Worth; museum purchase; 318.68
- Los Angeles County Museum of Art, Los Angeles; museum purchase with county funds; M.70.81.66
- Museum of Modern Art, New York City; gift of Kleiner, Bell and Company; 534.69
- National Gallery of Art, Washington, D.C.; gift of Dorothy J. and Benjamin B. Smith; 1984.34.313
- Newark Public Library, Newark; partial gift of the artist and partial museum purchase; M636.16.61
- Norton Simon Museum, Pasadena,

California; museum purchase; 69.92.494

*Tablet Litho 16,** 1968 (July 3). Tamarind 2369, state II. Lithograph (aluminum) in black, 32 × 23 inches (sheet). Edition: 10 on Magnani Italia, plus 9 on copperplate deluxe. Printer: Theo Wujcik at Tamarind Lithography Workshop, Los Angeles.
• Amon Carter Museum of Western Art, Fort Worth; museum purchase; 319.68
• Los Angeles County Museum of Art, Los Angeles; museum purchase with county funds; M.70.81.67
• Museum of Modern Art, New York City; gift of Kleiner, Bell and Company; 535.69
• National Gallery of Art, Washington, D.C.; gift of Dorothy J. and Benjamin B. Smith; 1984.34.314
• Newark Public Library, Newark; partial gift of the artist and partial museum purchase; M636.17.61
• Norton Simon Museum, Pasadena, California; museum purchase; 69.92.495

*Tablet Litho 17,** 1968 (June 26–July 5). Tamarind 2367. Lithograph (stone) in two blacks, 34 × 23 inches (sheet). Edition: 20 on German etching paper, plus 9 on copperplate deluxe. Printer: Daniel Socha at Tamarind Lithography Workshop, Los Angeles.
• Amon Carter Museum of Western Art, Fort Worth; museum purchase; 316.68
• Los Angeles County Museum of Art, Los Angeles; museum purchase with county funds; M.70.81.64
• Museum of Modern Art, New York City; gift of Kleiner, Bell and Company; 532.69
• National Gallery of Art, Washington, D.C.; gift of Dorothy J. and Benjamin B. Smith; 1984.34.311
• Newark Public Library, Newark; partial gift of the artist and partial museum purchase; M636.14.61
• Norton Simon Museum, Pasadena, California; museum purchase; 69.92.492

*Tablet Litho 18,** 1968 (July 9–11). Tamarind 2368. Lithograph (stone) in white, 41 1/4 to 41 1/2 × 29 1/4 to 29 1/2 inches (sheet). Edition: 20, plus 9 on white Inomachi nacre paper. Printer: Robert Rogers at Tamarind Lithography Workshop, Los Angeles.
• Amon Carter Museum of Western Art, Fort Worth; museum purchase; 317.68
• Los Angeles County Museum of Art, Los Angeles; museum purchase with county funds; M.70.81.65
• Museum of Modern Art, New York

City; gift of Kleiner, Bell and Company; 533.69
• National Gallery of Art, Washington, D.C.; gift of Dorothy J. and Benjamin B. Smith; 1984.34.312
• Newark Public Library, Newark; partial gift of the artist and partial museum purchase; M636.15.61
• Norton Simon Museum, Pasadena, California; museum purchase; 69.92.493
• Whitney Museum of American Art, New York City; gift of Hillary Burns; 69.81

*Tablet Litho 19,** 1968 (July 5–13). Tamarind 2377. Lithograph (stone) in black and blue-black, 18 × 14 inches (sheet). Edition: 20, plus 9 on white Inomachi nacre paper. Printer: Theo Wujcik at Tamarind Lithography Workshop, Los Angeles.
• Amon Carter Museum of Western Art, Fort Worth; museum purchase; 322.68
• Los Angeles County Museum of Art, Los Angeles; museum purchase with county funds; M.70.81.70
• Museum of Modern Art, New York City; gift of Kleiner, Bell and Company; 538.69
• National Gallery of Art, Washington, D.C.; gift of Dorothy J. and Benjamin B. Smith; 1984.34.317
• Norton Simon Museum, Pasadena, California; museum purchase; 69.92.498

*Tablet Litho 20,** 1968 (July 5–13). Tamarind 2378. Lithograph (stone) in black and blue-black, 18 × 14 inches (sheet). Edition: 20, plus 9 on white Inomachi nacre paper. Printer: Theo Wujcik at Tamarind Lithography Workshop, Los Angeles.
• Amon Carter Museum of Western Art, Fort Worth; museum purchase; 323.68
• Los Angeles County Museum of Art, Los Angeles; museum purchase with county funds; M.70.81.71
• Museum of Modern Art, New York City; gift of Kleiner, Bell and Company; 539.69
• National Gallery of Art, Washington, D.C.; gift of Dorothy J. and Benjamin B. Smith; 1984.34.319
• Newark Public Library, Newark; partial gift of the artist and partial museum purchase; M636.19.61
• Norton Simon Museum, Pasadena, California; museum purchase; 69.92.499

*Tablet Litho 21,** 1968 (July 5–13). Tamarind 2393. Lithograph (aluminum) in two blacks, 33 1/2 × 23 1/2 inches (sheet). Edition: 20 on German etching paper, plus 9

on copperplate deluxe. Printer: Edward Hughes at Tamarind Lithography Workshop, Los Angeles.
• Amon Carter Museum of Western Art, Fort Worth; museum purchase; 335.68
• Los Angeles County Museum of Art, Los Angeles; museum purchase with county funds; M.70.81.83
• Museum of Modern Art, New York City; gift of Kleiner, Bell and Company; 551.69
• National Gallery of Art, Washington, D.C.; gift of Dorothy J. and Benjamin B. Smith; 1984.34.326
• Newark Public Library, Newark; partial gift of the artist and partial museum purchase; M636.25.61
• Norton Simon Museum, Pasadena, California; museum purchase; 69.92.511

*Tablet Litho 22,** 1968 (July 8–16). Tamarind 2375, state II. Lithograph (stone) in light yellow, 19 × 33 inches (sheet). Edition: 20 on German etching paper, plus 9 on copperplate deluxe. Printer: Anthony Stoeveken at Tamarind Lithography Workshop, Los Angeles.
• Amon Carter Museum of Western Art, Fort Worth; museum purchase; 320.68
• Los Angeles County Museum of Art, Los Angeles; museum purchase with county funds; M.70.81.68
• Museum of Modern Art, New York City; gift of Kleiner, Bell and Company; 536.69
• National Gallery of Art, Washington, D.C.; gift of Dorothy J. and Benjamin B. Smith; 1984.34.315
• Norton Simon Museum, Pasadena, California; museum purchase; 69.92.496

*Tablet Litho 23,** 1968 (July 14–16). Tamarind 2377, state II. Lithograph (stone) in silver-black, 18 × 14 inches (sheet). Edition: 20, plus 9 on German etching paper. Printer: Theo Wujcik at Tamarind Lithography Workshop, Los Angeles.
• Amon Carter Museum of Western Art, Fort Worth; museum purchase; 324.68
• Los Angeles County Museum of Art, Los Angeles; museum purchase with county funds; M.70.81.72
• Museum of Modern Art, New York City; gift of Kleiner, Bell and Company; 540.69
• National Gallery of Art, Washington, D.C.; gift of Dorothy J. and Benjamin B. Smith; 1984.34.318
• Norton Simon Museum, Pasadena, California; museum purchase; 69.92.500

*Tablet Litho 24,** 1968 (July 14–16). Tamarind 2378, state II. Lithograph (stone) in silver-black, 18 × 14 inches (sheet). Edition: 20, plus 9 on German etching paper. Printer: Theo Wujcik at Tamarind Lithography Workshop, Los Angeles.
- Amon Carter Museum of Western Art, Fort Worth; museum purchase; 325.68
- Los Angeles County Museum of Art, Los Angeles; museum purchase with county funds; M.70.81.73
- Museum of Modern Art, New York City; gift of Kleiner, Bell and Company; 541.69
- National Gallery of Art, Washington, D.C.; gift of Dorothy J. and Benjamin B. Smith; 1984.34.320
- Newark Public Library, Newark; partial gift of the artist and partial museum purchase; M636.20.61
- Norton Simon Museum, Pasadena, California; museum purchase; 69.92.501

*Tablet Litho 25,** 1968 (July 10–17). Tamarind 2376. Lithograph (aluminum) in silver-black, 23 × 34 inches (sheet). Edition: 15, plus 9 on German etching paper. Printer: Manuel Fuentes at Tamarind Lithography Workshop, Los Angeles.
- Amon Carter Museum of Western Art, Fort Worth; museum purchase; 321.68
- Los Angeles County Museum of Art, Los Angeles; museum purchase with county funds; M.70.81.69
- Museum of Modern Art, New York City; gift of Kleiner, Bell and Company; 537.69
- National Gallery of Art, Washington, D.C.; gift of Dorothy J. and Benjamin B. Smith; 1984.34.316
- Newark Public Library, Newark; partial gift of the artist and partial museum purchase; M636.18.61
- Norton Simon Museum, Pasadena, California; museum purchase; 69.92.497

*Tablet Litho 26,** 1968 (July 12–22). Tamarind 2379 and 2379A. Lithograph (stone) in purple and blue-black on two hinged sheets, 82 1/2 to 83 × 29 1/4 to 29 1/2 inches (total sheet). Edition: 20, plus 9 on white Inomachi nacre paper. Printer: Robert Rogers at Tamarind Lithography Workshop, Los Angeles.
- Amon Carter Museum of Western Art, Fort Worth; museum purchase; 326.68 and 327.68
- Cincinnati Museum of Art, Cincinnati; gift of Murray Kagel; 1970.734
- Los Angeles County Museum of Art,

Los Angeles; museum purchase with county funds; M.70.81.74 and M.70.81.75
- Museum of Modern Art, New York City; gift of Kleiner, Bell and Company; 542.60.a-b
- National Gallery of Art, Washington, D.C.; gift of Dorothy J. and Benjamin B. Smith; 1984.34.321.a
- Newark Public Library, Newark; partial gift of the artist and partial museum purchase; M636.21.62
- Norton Simon Museum, Pasadena, California; museum purchase; 69.92.502 and 69.92.503

*Tablet Litho 27,** 1968 (July 15–25). Tamarind 2391. Lithograph (stone) in two blacks, 33 × 23 inches (sheet). Edition: 20 on German etching paper, plus 9 on copperplate deluxe. Printer: Daniel Socha at Tamarind Lithography Workshop, Los Angeles.
- Amon Carter Museum of Western Art, Fort Worth; museum purchase; 331.68
- Los Angeles County Museum of Art, Los Angeles; museum purchase with county funds; M.70.81.79
- Museum of Modern Art, New York City; gift of Kleiner, Bell and Company; 547.69
- National Gallery of Art, Washington, D.C.; gift of Dorothy J. and Benjamin B. Smith; 1984.34.324
- Newark Public Library, Newark; partial gift of the artist and partial museum purchase; M636.24.61
- Norton Simon Museum, Pasadena, California; museum purchase; 69.92.507

*Tablet Litho 28,** 1968 (July 15–22). Tamarind 2380. Lithograph (aluminum) in light yellow-gray, 35 × 24 1/2 inches (sheet). Edition: 20 on copperplate deluxe, plus 9 on German etching paper. Printer: Serge Lozingot at Tamarind Lithography Workshop, Los Angeles.
- Amon Carter Museum of Western Art, Fort Worth; museum purchase; 330.68
- Los Angeles County Museum of Art, Los Angeles; museum purchase with county funds; M.70.81.78
- Museum of Modern Art, New York City; gift of Kleiner, Bell and Company; 546.69
- National Gallery of Art, Washington, D.C.; gift of Dorothy J. and Benjamin B. Smith; 1984.34.323
- Newark Public Library, Newark; partial gift of the artist and partial museum purchase; M636.23.62
- Norton Simon Museum, Pasadena,

California; museum purchase; 69.92.506
- Whitney Museum of American Art, New York City; gift of the artist; 72.143

*Tablet Litho 29,** 1968 (July 12–24). Tamarind 2379, state II, and 2379, state IIA. Lithograph (stone) in beige on two hinged sheets, 82 1/2 to 83 × 29 1/4 to 29 1/2 inches (total sheet). Edition: 10, plus 9 on white Inomachi nacre paper. Printer: Robert Rogers at Tamarind Lithography Workshop, Los Angeles.
- Amon Carter Museum of Western Art, Fort Worth; museum purchase; 328.68 and 329.68
- Los Angeles County Museum of Art, Los Angeles; museum purchase with county funds; M.70.81.76 and M.70.81.77
- Museum of Modern Art, New York City; gift of Kleiner, Bell and Company; 544.69.a-b
- National Gallery of Art, Washington, D.C.; gift of Dorothy J. and Benjamin B. Smith; 1984.34.322.a
- Newark Public Library, Newark; partial gift of the artist and partial museum purchase; M636.22.62
- Norton Simon Museum, Pasadena, California; museum purchase; 69.92.504 and 69.92.505

*Tablet Litho 30,** 1968 (July 22–28). Tamarind 2392, 2392A, and 2392B. Lithograph in (*a*) yellow-white, (*b*) dark gray, and (*c*) black on one of three hinged sheets, 27 1/4 × 20 1/4 inches (sheet). Edition: 10, plus 9 on German etching paper. Printer: Maurice Sanchez at Tamarind Lithography Workshop, Los Angeles.
- Amon Carter Museum of Western Art, Fort Worth; museum purchase; 332.68, 333.68, and 334.68
- Cincinnati Museum of Art, Cincinnati; gift of Murray Kagel, 1970.735; gift of the professional artists of Cincinnati in memory of Mrs. Jimmie Otten Gillespie, 1970.359
- Los Angeles County Museum of Art, Los Angeles; museum purchase with county funds; M.70.81.80, M.70.81.81, and M.70.81.82
- Museum of Modern Art, New York City; gift of Kleiner, Bell and Company; 548.69.a-c
- National Gallery of Art, Washington, D.C.; gift of Dorothy J. and Benjamin B. Smith; 1984.34.325.a
- Norton Simon Museum, Pasadena, California; museum purchase; 69.92.508, 69.92.509, and 69.92.510

EXHIBITIONS

GROUP EXHIBITIONS

1947 Michigan State University, East Lansing, Michigan (also 1948, 1949)

1956 Denver Museum, Denver: "Metropolitan Show"

1957 Children's Museum, Denver

Denver Museum, Denver: "Young Talent Group Show"

1958 Black Tulip Gallery, Dallas: "Texas Painting"

Holiday in Dixie, Shreveport, Louisiana

New York City Center Gallery, New York City (also 1959)

Texas Fine Arts Association, Dallas, Texas

1959 Art Directions Gallery, New York City: "Second Annual Group Show"

Riverside Museum, New York City

1961 Whitney Museum of American Art, New York City*

1962 Mortimer Brandt Gallery, New York City: "New York City Unusual Talent Show"*

Preston Gallery, New York City: "Unusual Talent Show"*

1964 Aldrich Museum of Contemporary Art, Ridgefield, Connecticut: "Selections from the Larry Aldrich Contemporary Collection, 1951–1964"*

Hanover Gallery, London*

Vassar College, Poughkeepsie, New York*

1965 Museum of Modern Art, New York City: "New Acquisitions"*

Andrew Dickson White Museum of Art, Cornell University, Ithaca, New York*

1967 Loeb Student Center, New York University, New York City*

1968 Bradford, England: "First British International Print Biennale"*

Dayton Art Institute, Dayton†

Margo Leavin Gallery, Los Angeles: "Selected Graphics by Foremost Contemporary Artists"*

Whitney Museum of American Art, New York City*

1969 Aldrich Museum of Contemporary Art, Ridgefield, Connecticut: "Survey of Contemporary Art"*

Martha Jackson Gallery, New York City: "Wallworks"*

Pennsylvania Academy of Fine Arts, Philadelphia*

1970 Indianapolis Museum of Art, Indianapolis: "Painting and Sculpture Today"†

New Gallery, Cleveland*

1971 Museum Galleries, Cooper Union: "22=44, Innovation '71"

Whitney Museum of American Art, New York City: "Oversized Prints"*

Whitney Museum of American Art, New York City: "Twentieth Century"*

Whitney Museum of American Art, New York City: "Women's Show"†

1972 Aldrich Museum of Contemporary Art, Ridgefield, Connecticut*

Art Gallery, Brainerd Hall, State University of New York College, Potsdam, New York: "Women in Art: An Exhibition of Painting and Sculpture"†

Columbus Museum of Art, Columbus, Ohio†

Finch Museum, New York City: "Prints from Hollanders Workshop"†

University of Utah, Salt Lake City: "Drawing and Painting Annual"†

1973 Akron Art Institute, Akron†

Newark Museum, Newark: "Beyond Easel Painting"

1974 Indianapolis Museum of Art, Indianapolis: "Painting and Sculpture Today 1974"

*Minimalist work.
†Neo-expressionist work.

Museum of Modern Art, New York City: "Printed, Cut, Folded, and Torn"*

Whitney Museum of American Art, New York City*

1975 Zellag Gallery, London (also 1976)*

1977 Virginia Museum of Fine Arts, Richmond, Virginia*

Weatherspoon Art Gallery, University of North Carolina, Greensboro: "Art on Paper"†

1979 Herbert F. Johnson Museum of Art, Cornell University, Ithaca, New York: "Cornell University Department of Art Faculty Exhibition" (also annually 1980–90)*†

1980 OK Harris Gallery, New York City (also 1981)†

Upstairs Gallery, Ithaca, New York (also annually 1981–84)†

1982 Mary Baskett Gallery, Cincinnati (also annually 1983–86)*

Webb-Parsons Gallery, New Canaan, Connecticut (also 1983)†

1983 Herbert F. Johnson Museum of Art, Cornell University, Ithaca, New York: "Women Artists: Selected Works from the Collection"*

1984 Los Angeles County Museum of Art, Los Angeles: "Twenty-five Year Tamarind Retrospective"*

Navy Pier, Chicago: "Chicago's International Art Exposition"*

New Acquisitions Gallery, Syracuse, New York: "Paper in the Works"*

1986 Art and Culture Center, Hollywood, Florida†

Headley-Whitney Museum, Lexington, Kentucky*

1960 Pietrantonio Gallery, New York City*

1963 Pace Gallery, Boston*

1964 Pace Gallery, New York City (also 1965)*

1965 Loeb Student Center, New York University, New York City*

1968 Grand Central Moderns Gallery, New York City*

1970 OK Harris Gallery, New York City: studio show†

1971 OK Harris Gallery, New York City (also annually 1972–74)†

1973 Webb-Parsons Gallery, Bedford Village, New York†

1975 Jordan Gallery, London*

1981 Wells College, Aurora, New York†

1983 Mary Baskett Gallery, Cincinnati (also 1984, 1985, 1988)*

REVIEWS, ARTICLES, AND CATALOGUES

1958 Eugene Lewis. "Art Notes." *Dallas Times Herald*, January 26.

1960 Carlyle Burrows. "A Fresh Season Begins Promptly." *New York Herald Tribune*, September 11, sec. 4 (review of show at Pietrantonio Gallery).

James R. Mellow. "In the Galleries." *Arts Magazine*, September, p. 65 (review of show at Pietrantonio Gallery).

1964 *Arts Magazine*, February (review of solo show at Pace Gallery).

Suzi Gablik. "Reviews and Previews: New Names This Month." *Art News*, February, p. 18 (review of solo show at Pace Gallery).

"Old Hundred," Opening Exhibition: Selections from the Larry Aldrich Contemporary Collection, 1951–1964. Ridgefield, Conn.: Aldrich Museum of Contemporary Art.

Visitors East, February (review of solo show at Pace Gallery).

1966 "Artist Wins Guggenheim Fellowship." *Asbury Park Evening Press*, April 4.

"College Art Teacher Granted Study Award." *Asbury Park Evening Press*, May 18.

1970 *Painting and Sculpture Today*. Indianapolis: Indianapolis Museum of Art.

1971 *Arts Magazine*, April (review of solo show at OK Harris Gallery).

Gordon Brown. "New York Galleries." *Arts Magazine*, April, p. 92 (review of show at OK Harris Gallery).

Tamarind: A Renaissance of Lithography. Los Angeles: Tamarind Lithography Workshop.

1972 *Arts Magazine*, June (review of solo show at OK Harris Gallery).

Art News, Summer (review of solo show at OK Harris Gallery).

Women in Art. Potsdam, N.Y.: Art Gallery, Brainerd Hall, State University of New York College at Potsdam.

1974 *Painting and Sculpture Today 1974*. Indianapolis: Indianapolis Museum of Art.

1979 Jeanne Mackin. "Faculty Art Show Is a Mixed Bag." *Ithaca Journal*, September 29.

1980 Jeanne Mackin. "Upstairs Trio Offers Wide Range." *Ithaca Journal*, May 10.

Carol Spence. "Cherished Simplicity." *Ithaca Times*, May 8–14.

1983 *Women Artists: Selected Works from the Collection*. Ithaca, N.Y.: Herbert F. Johnson Museum of Art, Cornell University.

1984 Sherry Chayat. "Exhibition Not Papered Over." *Syracuse Herald American Stars Magazine*, September 30.

1988 Laura Wesley. "Gayil Nalls, Claudia DeMonte, Ivy Parsons, Eleanore Mikus." *Q, A Journal of Art*, July, pp. 28–31.

CHRONOLOGY

Mikus (18 months), brother Theodore (3 1/2), and sister Helen (5 1/2)

Mikus in her studio on Jefferson Street, New York City, in 1960

1927 Born in Detroit (July 25) to Bertha Englot, a surgical-garment designer, and Joseph Mikus, a farmer and precision toolmaker. The third of four children.

1932–41 Attends kindergarten and elementary school in Detroit. Wins first prize in drawing in kindergarten.

1942–46 Attends Immaculata High School, an all-girl Catholic school in Detroit. Excels in sports, collaborates on a mural, studies piano, and takes college-preparatory courses. Studies painting and life drawing Saturdays and evenings at the School of Arts and Crafts in Detroit.

1946–49 Attends Michigan State University. Majors in art (painting). Leaves after junior year. Studies Spanish and lacquer painting at the University of Mexico (summer 1948). Group shows at Michigan State University.

1950–52 Goes to Europe. Travels and paints extensively in Germany and Austria.

1953–55 Returns to the United States and settles in Augusta, Georgia.

1956–57 Attends the University of Denver. Receives a Bachelor of Fine Arts in painting and history of art. Group shows at the Children's Museum and the Denver Museum, Denver.

1958 Moves to Austin, Texas. Does contemporary abstract expressionist work showing awareness of de Kooning, Kline, and Pollock. Group shows at the Black Tulip Gallery, Dallas; Holiday in Dixie, Shreveport, Louisiana (awarded monetary prize); the New York City Center Gallery; and the Texas Fine Arts Association, Dallas.

1959 Moves to Rahway, New Jersey. Attends the Art Students League, New York University, and the New York Art Institute. Group shows at the Art Directions Gallery and the Riverside Museum, New York City.

1960 Moves to Eighty-eighth Street in New York City and then to a loft studio at 76 Jefferson Street. Arranges to go into Section Eleven Parsons Junior Gallery, which never opens. First solo show, at the Pietrantonio Gallery, New York City (geometric and sectional canvases joined together).

1961–62 Moves to a fourth-floor loft studio at 429 Broome Street, Hell's Hundred Acres (later known as SoHo). Group shows at the Whitney Museum of American Art, the Mortimer Brandt Gallery (*Tablets 2* and *6*), and the Preston Gallery, New York City.

1963 Works in flat white enamel using Weldwood glue. First paperfold flier mailed by the Pace Gallery. Teaches painting with the Community Board of Education and the Special Services Department, New York City. First solo show of tablets, at the Pace Gallery, Boston.

1964 Uses medium of synthetic polymer emulsion. Dorothy Miller at the Museum of Modern Art, New York City, chooses a tablet (gift of Louise Nevelson). Second paperfold flier sent out by the Pace Gallery. Solo show of gray and white tablets at the Pace Gallery, New York City. Group shows at the Aldrich Museum of Contemporary Art, Ridgefield, Connecticut; the Hanover Gallery, London; and Vassar College, Poughkeepsie, New York.

1965 Solo shows at the Loeb Student Center, New York University; and the Pace Gallery, New York City. Group shows at the Museum of Modern Art, New York City; and the Andrew Dickson White Museum of Art, Cornell University, Ithaca, New York.

1966 Becomes an assistant professor of art at Monmouth College, West Long Branch, New Jersey. Teaches painting, art appreciation, sculpture, and basic design. Works in epoxy paint and epoxy glue; goes over earlier paintings to strengthen surfaces. Guggenheim fellow in painting. Works on a series of large, black paintings using epoxy paint and polyurethane paint. Studies oriental art. Asia House member.

1967 Receives a Master of Arts in oriental art history from the University of Denver. Group show at the Loeb Student Center, New York University.

1968 Tamarind fellow in lithography. Does thirty-two editions, working mainly with printers Robert Rogers and Serge Lozingot. Solo show at the Grand Central Moderns Gallery, New York City. Group shows (prints) at "First British International Print Biennale," Bradford, England; the Dayton Art Institute, Dayton; the Margo Leavin Gallery, Los Angeles; and the Whitney Museum of American Art, New York City.

1969 MacDowell fellow in painting (summer). Returns to Monmouth College. Group shows at the Aldrich Museum of

Mikus in her Jefferson Street studio with *Tablet 84* in 1963 (photo by Penney)

Mikus in her Broome Street studio in 1966 (photo by Diane McKowan)

Mikus in front of her church studio in Groton, New York, in 1988 (photo by Ed Peterson)

Contemporary Art, Ridgefield, Connecticut; the Martha Jackson Gallery, New York City; and the Pennsylvania Academy of Fine Arts, Philadelphia.

1970 Shows neo-expressionist work for the first time. Solo studio show at the OK Harris Gallery, New York City. Group shows at the Indianapolis Museum of Art and the New Gallery, Cleveland.

1971 Visiting lecturer in painting at Cooper Union, New York City. Teaches painting and drawing. Solo show at the OK Harris Gallery (neo-expressionist work). Group show at Cooper Union and the Whitney Museum of American Art, New York City.

1972 Solo show at the OK Harris Gallery, New York City (neo-expressionist mylars). Group shows at the Aldrich Museum of Contemporary Art, Ridgefield, Connecticut; the Columbus Museum of Art, Columbus, Ohio; the Finch Museum, New York City; the State University of New York College at Potsdam; and the University of Utah, Salt Lake City.

1973 Goes to London. Teaches at the Central School of Art (October 1973–June 1977). Solo shows at the OK Harris Gallery, New York City (red and black paintings); and the Webb-Parsons Gallery, Bedford Village, New York. Group shows at the Akron Art Institute and the Newark Museum.

1974 Teaches at Kensington Institute, London (September 1974–June 1977). Solo shows at the OK Harris Gallery (neo-expressionist mylars). Group shows at the Indianapolis Museum of Art; the Museum of Modern Art, New York City; and the Whitney Museum of American Art, New York City.

1975–76 Lecturer in painting at Harrow College of Art and Technology, Northwick Park, Harrow, England. Solo show at the Jordan Gallery, London (prints). Group show at the Zellag Gallery, London (prints).

1977 Returns to New York City. Group shows at the Virginia Museum of Fine Arts, Richmond; and the Weatherspoon Art Gallery, University of North Carolina, Greensboro.

1978 Takes a studio in the East Side Airlines Terminal, New York City. Begins black and white painting.

1979 Becomes an assistant professor of art at Cornell University, Ithaca, New York. Annual faculty shows from 1979 to present in the Herbert F. Johnson Museum of Art at Cornell.

1980 Becomes an associate professor of art at Cornell. Shows at the OK Harris Gallery, New York City (paperfolds); and the Upstairs Gallery, Ithaca, New York.

1981 Solo show at Wells College, Aurora, New York. Shows at the OK Harris Gallery, New York City; and the Upstairs Gallery, Ithaca, New York.

1982 Group shows at the Mary Baskett Gallery, Cincinnati; the Upstairs Gallery, Ithaca, New York; and the Webb-Parsons Gallery, New Canaan, Connecticut.

1983 Solo show at the Mary Baskett Gallery, Cincinnati (paperfolds). Group shows at the Mary Baskett Gallery; the Herbert F. Johnson Museum of Art, Cornell University, Ithaca, New York; the Upstairs Gallery, Ithaca; and the Webb-Parsons Gallery, New Canaan, Connecticut.

1984 Buys and begins to renovate an 1823 church in Groton, New York, into a working studio. Solo show at the Mary Baskett Gallery, Cincinnati. Group shows at the Mary Baskett Gallery; "Chicago's International Art Exposition," Navy Pier, Chicago; the Los Angeles County Museum of Art; the New Acquisitions Gallery, Syracuse, New York; and the Upstairs Gallery, Ithaca, New York.

Mikus in 1990 (photo by Lee Melen)

1985 Is granted tenure at Cornell. Receives a Women's Development Fund Grant. Solo show and group show at the Mary Baskett Gallery, Cincinnati.

1986 Moves into the church studio. Group shows at the Art and Culture Center, Hollywood, Florida; the Mary Baskett Gallery, Cincinnati; and the Headley-Whitney Museum, Lexington, Kentucky.

1987 Travels to Key West, Fort Lauderdale, and Miami, Florida.

1988 Starts cataloguing life's work. Goes to Rome. Solo show at the Mary Baskett Gallery, Cincinnati.

1989 Teaches at Cornell-in-Rome. Travels extensively in Italy, Turkey, and Greece. Returns to the United States and resumes teaching at Cornell. Completes the church studio.

1990 On leave from Cornell. Continues working in the church studio.

PHOTOGRAPH CREDITS